BACKYARD BIRD PHOTOGRAPHY

BACKYARD BIRD PHOTOGRAPHY

HOW TO ATTRACT BIRDS TO YOUR HOME AND CREATE
BEAUTIFUL PHOTOGRAPHS

Mathew Tekulsky

Skyhorse Publishing

Skyhorse Publishing books may be purchased in bulk at special
discounts for sales promotion, corporate gifts, fund-raising,
or educational purposes. Special editions can also be created to
specifications. For details, contact the Special Sales Department,
Skyhorse Publishing, 307 West 36th Street, 11th Floor, New York, NY
10018 or info@skyhorsepublishing.com.

Skyhorse® and Skyhorse Publishing® are registered trademarks of Skyhorse
Publishing, Inc. ®, a Delaware corporation.

www.skyhorsepublishing.com

10 9 8 7 6 5 4 3 2

ISBN: 978-1-62873-740-0

Library of Congress Cataloging-in-Publication Data is available on file.

Printed in China

Thanks, as always,
to my mother

CONTENTS

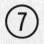

Acknowledgments

I would like to thank everyone who has encouraged me with my bird photography. At Skyhorse Publishing, a warm note of appreciation to my editor, Kristin Kulsavage, and to Tony Lyons. Thanks, as well, to my literary agent, Peter Beren.

Scrub Jay

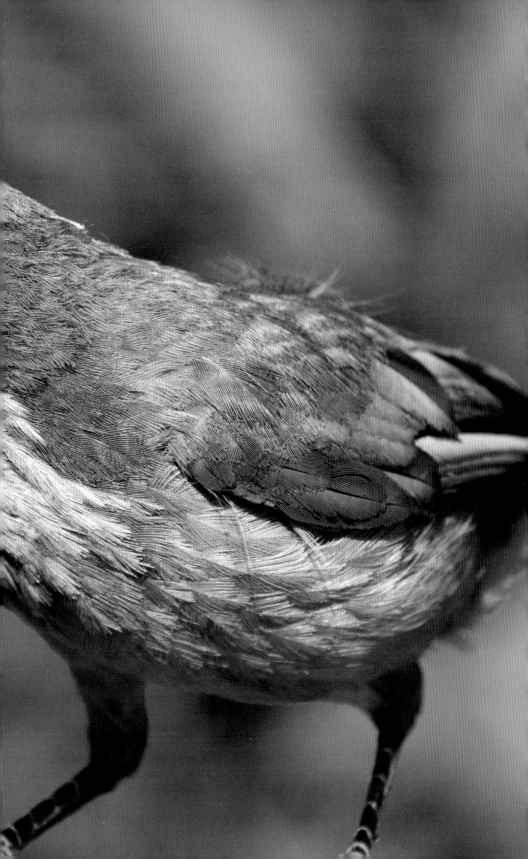

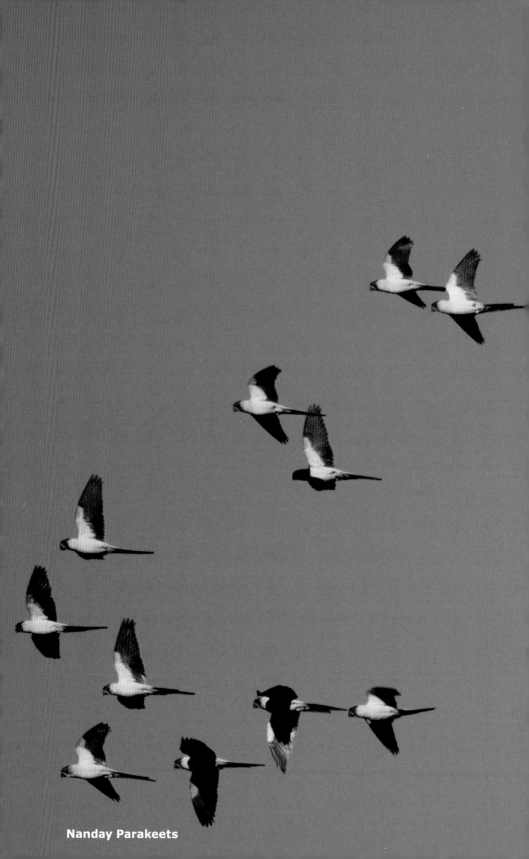

Nanday Parakeets

① Introduction

"The very idea of a bird is a symbol and a suggestion to the poet."

—John Burroughs, *Birds and Poets*

One of the great joys in life is to watch birds. People have been doing this for as long as people have been on this planet, and humankind reveres the bird in virtually every culture on earth. With the advent of photography, we have had the ability to capture these beautiful creatures on film, and now digitally, and to enjoy looking at these images and sharing them in various ways, either on social networks on the Internet, through print publishing, or even in a frame on our walls or in galleries or museums.

In this book, you will learn how to set up your backyard in order to take the best photographs of your own particular birds as you can. In addition to guiding you through the first steps of setting up your plantings and birdfeeders, this book will describe the types of photographic equipment you will need to get just the right image; how to maneuver yourself into just the right position to create a quality bird photograph; how to compose your shots for the greatest visual effect; and how to use more advanced techniques such as macro lenses and external flash techniques.

My bird photography journey has taken place over the better part of twenty years, starting with film and transitioning to the digital age.

As I look back over the years, I marvel at how rudimentary my knowledge of birds and bird photography was at the beginning, and I am proud of how much I have learned since then. You can follow this same path and enjoy the rewards along the way.

The most important aspect of this whole activity is the process, the actually "doing" of it. When I am engaged in photographing birds, nothing else matters to me. It's all about getting the shot. Whatever "Zen" is, that's it. All of your cares wash away—you don't worry about yesterday or tomorrow. There is only the *now*. And in a funny way, I think this is how the birds think as well. Of course, the birds are busy foraging for food and making sure a predator does not attack them, but beyond these immediate concerns, I believe there is a part of bird psychology that is observant and even playful. Especially when they're interacting with me.

Part of the challenge, then, in taking a great bird photograph is to capture that emotional element of the bird's life and how the bird is interacting with the photographer. As in all great art, it is the emotion

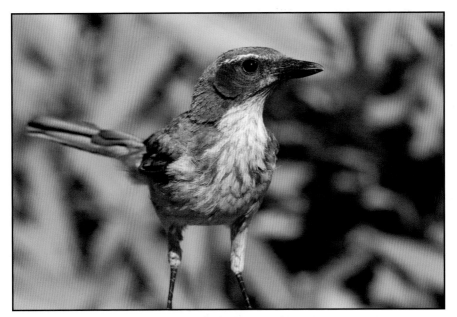

Scrub Jay portrait

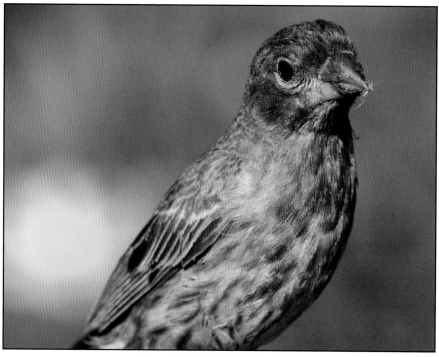

House Finch

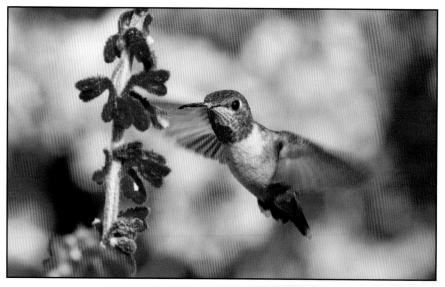

Allen's Hummingbird at Mexican sage

that counts. If there is no emotional reaction to a work of art, then all the technique in the world is of little significance. What gives the backyard bird photographer an edge over the photographer of birds in wilderness areas is that the birds in your backyard are familiar with you, they are your friends, even your family. They have been living next to you for years, and in many ways, they own your abode as much as you do. They get up in the morning as you do, and retire at night not far from where you sleep. It's no wonder that a great bird photograph taken in your own yard can rival a bird photograph taken anywhere in the world, and by anybody. So I encourage you to take advantage of your own natural surroundings and experience the Zen of bird photography as I do.

The Ansel Adams of bird photography was an Englishman by the name of Eric Hosking, who lost his left eye when a Tawny Owl attacked him during a photo shoot. He was then just 27 years old. Within twenty-four hours of being discharged from the hospital, where the damaged eye was removed, Hosking was back at the owl site, but the young owls had already flown. The following year, he returned to

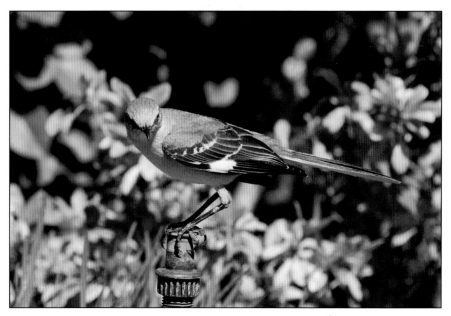

Northern Mockingbird on sprinkler head

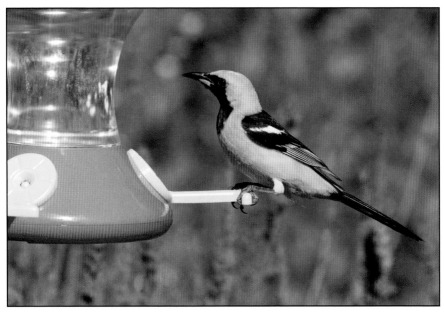

Hooded Oriole

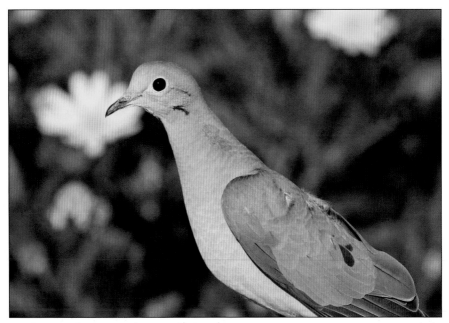

Mourning Dove

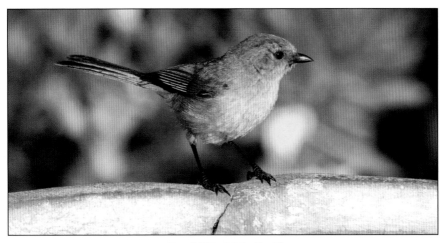

Bushtit at birdbath

the same place and photographed those very owls. He continued to photograph birds for the rest of his long, illustrious career.

Hosking's story gives me inspiration every time I go out to photograph birds. I figure, if Hosking could do it, so could I, and so this pursuit has become a lifelong occupation for me.

In his book *Bird Photography as a Hobby*, which has a chapter entitled "Bird Photography at Home," Hosking states so eloquently what I feel as well about this subject:

> There can be few activities which surpass bird photography as an occupation for the leisure hours of anyone who is young in heart. Here we have an absorbing hobby which will appeal to the photographer and to the scientist, but will no less offer an opportunity for artistic expression to all those who love to see, and be with, Nature.

This, in the end, is what it's all about—the natural world, and preserving the open spaces and the various forms of wildlife that use these areas. If our backyards can become oases for the birds across the country, then the environment can be enhanced and we can benefit from the personalities of these creatures as we cohabit these spaces. And if we apply our creativity and produce some great bird photographs along the way, so much the better.

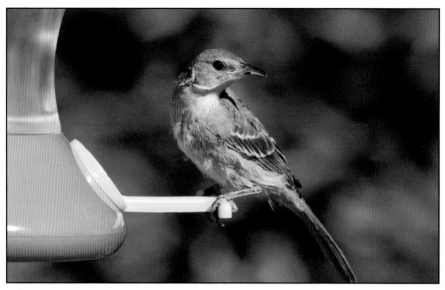

Hooded Oriole juvenile

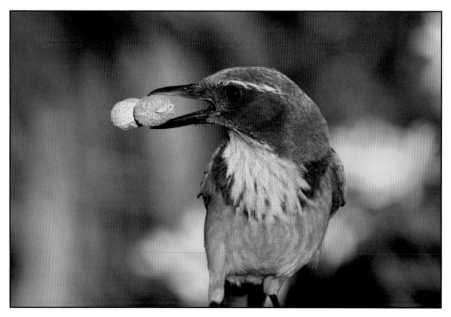

Scrub Jay with peanut

The bird species that I feature in this book are unique to my experience, but the same principles of bird photography that work in my garden will work with the birds that visit your home. In my case, the cast of characters includes a few standouts, such as the Western Scrub-Jay (hereafter referred to as the Scrub Jay), Allen's Hummingbird, and Hooded Oriole. I seem to spend much of my time photographing these three species, but there are about thirty species that visit my backyard in the Brentwood Hills of Los Angeles throughout the year.

The following species visit my yard every day: Scrub Jay, Allen's Hummingbird, California Towhee, House Finch, Mourning Dove, Song Sparrow, California Thrasher, Lesser Goldfinch, California Quail, and Nanday Parakeet. Then there are the species that visit the yard on any given day throughout the year, but not necessarily every day: Anna's Hummingbird, Northern Mockingbird, Bushtit, Nuttall's Woodpecker, Acorn Woodpecker, Oak Titmouse, Wrentit, Black Phoebe, and Band-tailed Pigeon. During the winter, the following species are in the yard every day: Golden-crowned Sparrow, White-crowned Sparrow, Fox Sparrow, Dark-eyed (Oregon) Junco, Yellow-rumped Warbler, and American Robin. On any given winter day, I

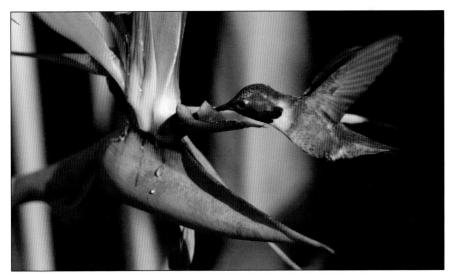

Allen's Hummingbird at bird of paradise

Hooded Oriole at bird of paradise

might see the Hermit Thrush as well. The Black-chinned Humming-bird is a regular visitor to the garden during the spring and summer.

Other species that have visited my garden include the Pine Siskin, Ruby-crowned Kinglet, Red-breasted Nuthatch, and Orange-crowned Warbler. The Phainopepla sometimes appears in June or earlier, and the Black-headed Grosbeak occasionally appears in the spring and summer. The American Crow flies around the neighborhood every day, but rarely visits my garden. Two one-time visitors were the Western Tanager and the Bullock's Oriole.

The Hooded Oriole is in the yard every day from the middle of March through early September. Generations of this species have been raising their young every summer in my yard for as long as I have been here, which is over thirty years. They know this yard and the male usually appears in the late morning around March 15 or so, and I put out the oriole feeder with the sugar water. The female usually arrives a few days later, and they raise their young in a nest built in

a palm tree partway down the hill on the canyon side of my garden. When the young orioles leave the nest, there may be as many as five or six of them drinking sugar water from my oriole feeder. One year, I even put out two oriole feeders at the same time, and the perches filled up with the young ones very quickly. By the second week of September, the orioles have departed on their migration south to their wintering grounds in Mexico, the male usually leaving first, then the female, while the fledglings stick around until they've had their fill of sugar water and then one day, they're gone. It's heart-wrenching to see these little things disappear every year and know that I have to face the winter here alone without them flying around and chattering at each other. But I have my memories of the previous summer to keep me going, and the prospect of their return the following spring. How the young birds only weeks old know where to go in Mexico to meet up with their family is beyond me, as they always leave last and alone.

Most of the birds in my yard require different techniques for photographing them. For instance, the Scrub Jay loves peanuts, so I can keep him in the yard for hours just by putting out some peanuts. In the case of the Allen's Hummingbird, some sugar water in a hummingbird feeder and a few good hummingbird flowers such as fuchsia, bird of paradise, and Mexican sage do the trick. Meanwhile, the

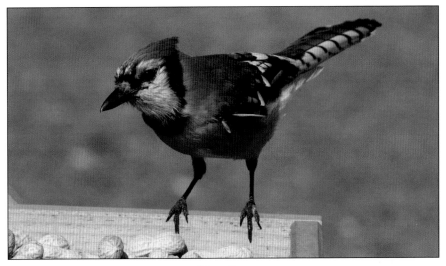

Blue Jay

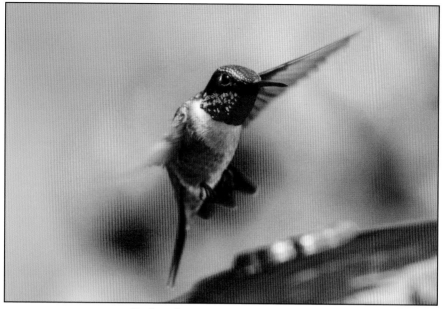

Ruby-throated Hummingbird

Hooded Oriole enjoys feeding from his own special feeder, which gives him a big perch on which to land, but he also takes nectar from the bird of paradise flower. As long as the birds are content in their environment, you can bide your time and wait for the right moment to take a great photograph.

I live on a hill overlooking Sullivan Canyon in the Brentwood Hills section of Los Angeles, which gives me a transition zone where birds fly up from the canyon to visit my yard each day. Many of them return to the canyon to roost at night. For instance, just as the sun is going down, the Scrub Jays start flying off across the canyon to their roosting site in the scrub oaks. It's amazing to watch their flight pattern as they flap a few times, gain altitude, and then drop down a bit, only to flap again to gain altitude, and so on, getting lower and lower to the ground as they go, finally landing in the trees, where I can hardly see them. But they are home. The next day, the process starts all over again.

The Hooded Oriole nests in a palm tree partway down the hill from my garden, and he flies about one hundred feet every time he wants to visit the oriole feeder. The Allen's Hummingbird stays in the yard most

of the day, chasing off all competitors including the Anna's and Black-chinned Hummingbirds, and I am sure he roosts in a tree nearby, just to be sure of his territory. The California Quail walk through the garden every day, having climbed up the hill from the canyon.

All of this activity takes place just a five-minute drive from Sunset Boulevard, which lies at the base of the hill where I live. This famous road goes from Hollywood to the Pacific Ocean and is just north of Brentwood and Santa Monica where I meet it. So the proximity to a major metropolitan area makes my garden an extremely valuable feature in my life, providing me with the joys of nature while still being part of a major city.

Seasonality plays a large role in the functioning of my bird garden for photography. From April through September there is the most activity, as the spring migrants pass through and the resident birds take to the nest and rearing of the young. In the winter, the White-crowned, Golden-crowned, and Fox Sparrows arrive from the north and utilize my birdseed while they wait to migrate back north the following spring. The Yellow-rumped Warbler appears in the winter as well, eating the sumac in the canyon below me, but using my birdbath almost every day. The American Robin is also a winter visitor, using the pyracantha berries across the street from me for food, but using my birdbath for drinking and bathing early every morning. Mostly in the spring and summer, the Band-tailed Pigeon finds the yard and descends to the platform feeder for some birdseed, or the birdbath for a drink. Same with the Black-headed Grosbeak, who usually makes an appearance with his mate. Of course, the regulars in the yard, such as the Song Sparrow, House Finch, California Towhee, and Spotted Towhee are my sentimental favorites, as somehow with birds, familiarity does not breed contempt.

The point of all of this is that wherever your backyard bird photography takes place, you will be treated to the unique circumstances of bird species and behaviors that your particular location features. If you take advantage of all that your surroundings have to offer, you need only to augment them with a few good plants and a few good birdfeeders and you are off to the races as far as bird photography is concerned.

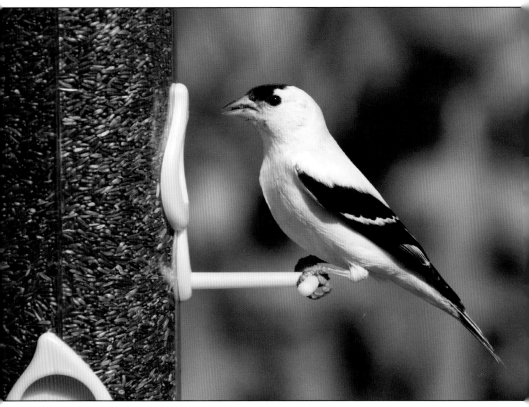

American Goldfinch

In addition to information about my garden in Los Angeles, this book also features a garden at a family home in Adamant, Vermont, which is just outside of Montpelier. Whenever I visit this garden, I make the most of it and photograph birds from sunup to sundown. I have managed to build a nice collection of images in the time I have spent there, and I feel as akin to the Blue Jay, Ruby-throated Hummingbird, Black-capped Chickadee, American Goldfinch, and Purple Finch in Vermont as I do to my Los Angeles species. It is always a painful parting to leave the Blue Jay behind, with all of his antics, and to think of the Ruby-throated Hummingbird preparing for his autumn migration always fills me with a longing to spend just a little more time with him before I migrate back to Los Angeles.

I once had this notion that the whole world is a backyard, and that if everyone just treated wherever they went as their own backyard,

the world would be a much better place. If the whole world becomes one big backyard bird garden with millions of backyard bird photographers creating beautiful images every day—that would be just all right with me.

Allen's Hummingbird

②

Setting Up
Your Garden

"A phoebe soon built in my shed, and a robin for protection in a pine which grew against the house."
—Henry David Thoreau, *Walden*

It wasn't always like this. Over the years, I have become accustomed to the goings and comings of the birds in my garden. But what brings them here in the first place, and what makes them stay here year after year, when they are free to go wherever they like?

Well, it's just like with people. If you provide the birds with the creature comforts they require, they will be prone to stay in your yard. The primary ingredients are food, water, and shelter.

Food for the birds can be provided with the plantings you have in your yard as well as with a wide assortment of birdfeeders. In my Los Angeles garden, the resident Allen's Hummingbird takes nectar from the following flowers: fuchsia, star clusters, bird of paradise, lavender, bear's breeches, Mexican sage, and bottlebrush, among others. But this hummingbird, as well as the Anna's Hummingbird and Black-chinned Hummingbird, takes advantage of my hummingbird feeder and even the oriole feeder, which also contains sugar water. The Hooded Oriole also feeds on nectar from the bird of paradise and bottlebrush flowers when he is in the yard from March to September.

In my garden in Vermont, the Ruby-throated Hummingbird gorges on bee balm during the summer, as these vibrant, red flowers with their tubular blossoms form a symbiotic relationship with

the tiny birds that pollinate them. This hummingbird also feeds on the hosta flowers, and visits my hummingbird feeder every twenty minutes or so.

Most of the other plants in my Los Angeles garden are designed for providing shelter for the birds and colorful backdrops for my photographs. For instance, I have an oleander bush that runs along the southern side of the yard, and above this hedge a coast live oak tree rises majestically. While the ground-feeding birds such as the California Towhee, Song Sparrow, California Thrasher, and Spotted Towhee invariably appear in my yard from under this oleander bush, the Scrub Jay, House Finch, and Mourning Dove usually perch briefly in the oak tree (or an avocado tree on the adjacent property) before dropping down into the yard.

By getting to know the habits of the birds in your garden, you will be prepared for their arrival as you photograph them. I know, for instance, that when the Scrub Jay lands in the oak tree, that's his last stop before flying over to my green platform feeder, which lies atop a pole. Likewise, if I see some of the oleander branches start to shake, I know that there is a bird in there about to emerge, perhaps a Golden-crowned Sparrow or White-crowned Sparrow.

The oleander hedge in my garden provides a windbreak as well, so my enclosed area of plantings is like an oasis from the vicissitudes of the natural world—for the birds and for myself. If you listen carefully, you can hear the hum of the city in the background, but the chirps and whistles and screeches of the birds soon overshadow the city noise as the party begins each day.

As far as birdfeeders are concerned, I have a number of special feeders that I use in order to get the best bird photographs that I can. With the hummingbirds, I use a flying saucer-shaped feeder that allows the hummingbird to perch as well as hover. I use a sugar water solution of four parts water to one part sugar. To make the sugar water, I stir the sugar into hot water from my kitchen faucet in a measuring cup. Then I pour the solution into a plastic container and store the mixture in the refrigerator. I use a spare hummingbird feeder while I am not photographing, so my clean hummingbird feeder is brought out from the refrigerator each day just for that photography session.

Be sure to bring the feeder out with an hour to spare in order for the condensation to disappear on the outside of the feeder. In the evening, I bring the hummingbird feeder back into the house and either store it in the refrigerator overnight or empty the sugar water and use new, refrigerated sugar water the following day with a clean hummingbird feeder. (I use a spare platform feeder and a spare oriole feeder as well, for the same purpose.)

For seed-eating birds such as the Scrub Jay in Los Angeles and the Black-capped Chickadee in Vermont, I use a platform feeder attached to a pole. This feeder can be placed in front of some green foliage, like my oleander bush, and it can be turned so that the background features the yellow flowers of the bush daisy or the red flowers of the fuchsia, depending on where my camera is situated. I can also raise it or lower it, depending on how many sections of the pole I use. Many species of birds quickly learn that there is food on this platform, and they flock to it. I often put peanuts on this feeder for the Scrub Jay and try to get as close as I can to the bird in order to obtain an intimate portrait, with the yellow of the bush daisy flowers as a background. It is a challenge and you have to be fast on the shutter, but the rewards are spectacular.

The oriole feeder that I use has a pleasant, rounded shape and is used by the Hooded Oriole when he's here from March to September. This species is so skittish that for many years, he would rarely go to the feeder if I were outside on the patio, so I started using a "blind" from inside the house. To do this, I took a screen out from a sliding glass door in my TV room, and I put a large piece of cardboard at the bottom of the window area while pulling the window shade down from above, thus creating a small area through which I can photograph. The oriole knows I am there, but if I am very still he will go to the feeder, even when I move the feeder closer to the house. In this case, I have the pole mounted on a movable stand that makes it possible to change the location of the feeder.

Occasionally, I have all three of these feeders set up in my garden, just so I can enjoy the variety of birds, but more often than not, I use one of the feeders exclusively during a shoot. This is primarily because I do not want the other feeders cluttering up the background,

but also because it is better to concentrate on one setup than to jump from one type of shoot to another on the same day, at least for me. For instance, if I am in a hummingbird mood, I become attuned to the speed and habits of the hummingbird for that afternoon, or for that week. Likewise with the Scrub Jay, and certainly for the Hooded Oriole, who demands almost constant attention for his sporadic and brief visits to the oriole feeder. With the platform feeder, however, since numerous species visit this feeder, you can photograph a variety of birds all with the same setup, which is often gratifying. While I am not using a particular feeder in the main area of my garden, I move it to the canyon side of the pool, where I have some poles placed in the ground for just this purpose. I never want the birds to be without the

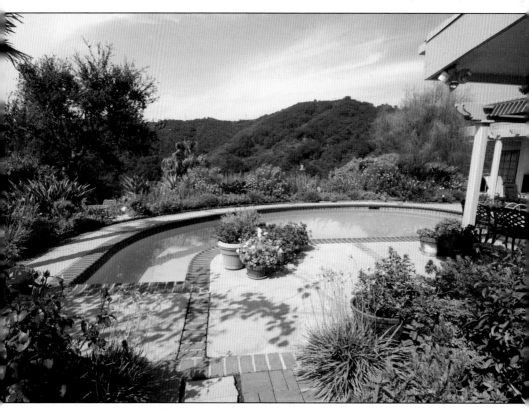

View of canyon side of pool in Los Angeles, with oriole feeder, Mexican sage, and Mexican marigold

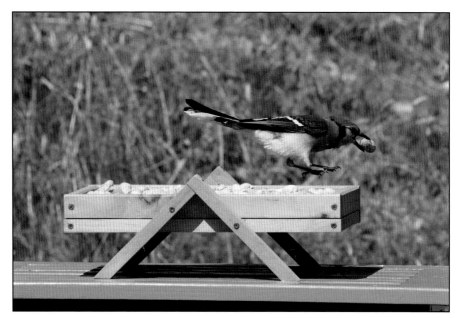

Blue Jay flying off wood platform feeder with peanut

food that they expect, as this allows me to photograph the bird of my choice most of the time.

I also use this area on the canyon side of the pool to photograph the Allen's Hummingbird, Black-chinned Hummingbird, and Hooded Oriole. I hang the hummingbird feeder or oriole feeder from a pole that is placed between the Mexican sage and the Mexican marigold plants. Here, I photograph hummingbirds while they drink the nectar from the Mexican sage flowers, and I use the golden Mexican marigold flowers as a background for the birds when they are using their respective feeders.

Some platform feeders can be placed directly on the ground or on a table. In Vermont, I use a wood platform feeder filled with peanuts to attract the Blue Jay (as well as the eastern chipmunk and American red squirrel), and I find that by placing the feeder on a table, I will not be photographing down so much on the bird and I will not have to bend down so much myself. One day in early July, as I was using the 100–400mm lens to photograph the Ruby-throated Hummingbird at the hummingbird feeder, I swiveled the camera to get a photograph of

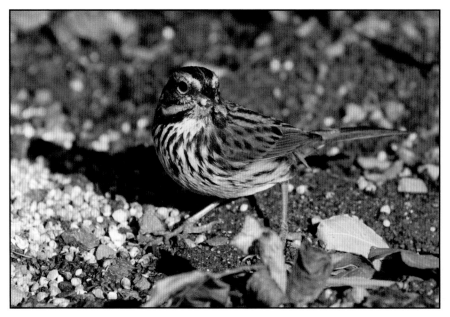

Song Sparrow

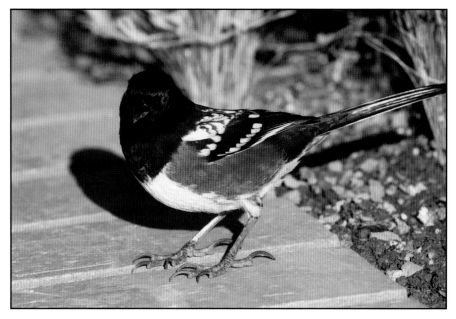

Spotted Towhee

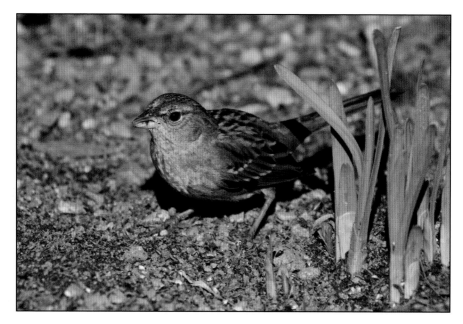

Golden-crowned Sparrow

the Blue Jay flying off from the wood platform feeder with a peanut. I also use black oil sunflower seeds, mixed birdseed, and a combination of mixed birdseed and peanuts with this wood platform feeder.

I use another wood platform feeder in Vermont by just placing it on the grass and filling it up with mixed birdseed, including plenty of black oil sunflower seeds that I add to the mixture. One summer day, I was trying to attract the Song Sparrow, but he wasn't enticed onto this feeder, and I had to resort to spreading mixed birdseed right on the grass, which is known as a ground feeder. I was eventually able to attract the Song Sparrow to this area and got a photograph of him amid the blades of grass.

I also use mixed birdseed for my ground feeder in Los Angeles, which simply consists of two small piles of birdseed in two open patches of dirt between the plants. When the birds move into the open area to collect the seed, I collect an image of the bird. By placing the birdseed in two separate spots, I can swivel the camera to whichever area is best lit by the sun at any given time, while I am sitting on

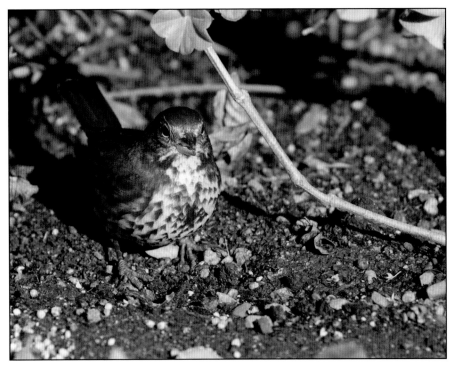

Fox Sparrow

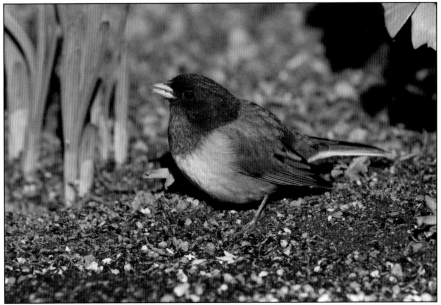

Dark-eyed (Oregon) Junco

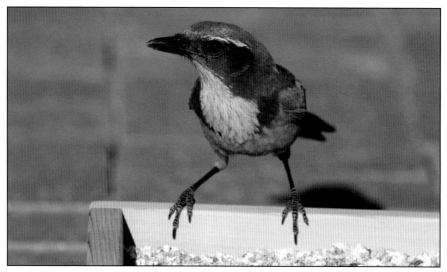

Scrub Jay at ground platform feeder

my 18-inch folding stool. The birds become accustomed to finding the food in these locations as well, so I have a ready audience.

I usually use my ground feeders during the winter, when the resident Song Sparrow and Spotted Towhee share the soil and the patio with the visiting Golden-crowned Sparrow, Fox Sparrow, and Oregon Junco. While each of these species will fly up to the platform feeder on the pole, they can be found more often than not foraging among the bushes. So why not bring yourself down to their level in order to photograph them? This requires sitting on my stool and hunching over for hours, but I get to interact with the birds in a natural way, and from very close range.

When I place my ground platform feeder on my brick patio in Los Angeles, I utilize a reddish, textured background for the photographs taken close to the ground, such as an image I got of the Scrub Jay one day in February. This setup has also produced some beautiful images of the California Quail. In one instance, I had hosed off the patio in order to clean up the background, but the water had not dried up yet, so when the quail arrived, there was still a glistening sheen on the bricks. In this image, the male California Quail seems to be doing a

pirouette as he crosses the path, while you can see the blurred body of the female California Quail in the background at left.

For the American Goldfinch in Vermont, and the Lesser Goldfinch in Los Angeles, I use a tube feeder that is specially designed to hold Nyjer seeds (a commercially grown thistle seed) for these birds, and for a few other species that have learned to use these feeders and that have bills that are adapted for it, such as the Pine Siskin and House Finch in Los Angeles, and the Black-capped Chickadee and Purple Finch in Vermont.

The Lesser Goldfinch is a tiny bird and he is very wary, but once he becomes used to using the Nyjer feeder in my Los Angeles garden, he is virtually tame. Even if I am not photographing, I can stand a few feet away from this feeder and the goldfinch just looks up at me and then goes back to his feeding. Similarly, when I am photographing the hummingbird from close range, the goldfinch will drop down to the birdbath right next to me, as if I weren't even there. He's a delightful little bird and he makes high-pitched whistles and chirps all the time,

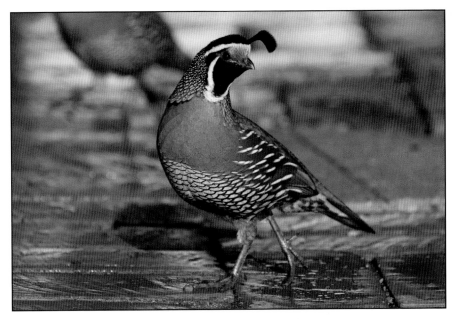

California Quail on patio

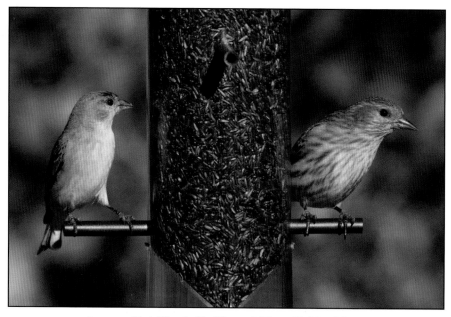

Lesser Goldfinch (left) and Pine Siskin (right)

so you always know he's there. It may take him a few days to find your Nyjer feeder, but once he does, he'll stay in your yard and he won't stop eating. (Nyjer seed is also very tasty to the Fox Sparrow, which eats this seed off the ground in Los Angeles when I set up a ground feeder.)

One day in Vermont, I put an assortment of birdfeeders in a row, in order to present the types of feeders you can use in your own garden. From left to right, in the photo on page 32: green platform feeder on a pole, with mixed birdseed; tube feeder with Nyjer seed; wood platform feeder with unshelled, unsalted, roasted peanuts; wood platform feeder with black oil sunflower seed; metal platform feeder with mixed birdseed; green platform feeder on a pole, with peanuts; ground feeder tray with mixed birdseed, to the right in the shade; and on a tripod behind the feeders, my Canon EOS 7D camera body with a Canon 100–400mm lens.

In Los Angeles, I lined up the feeders in the main part of the garden. From left to right, in the top photo on the next page: the oriole feeder, the Nyjer feeder, the green platform feeder on a pole, the hummingbird

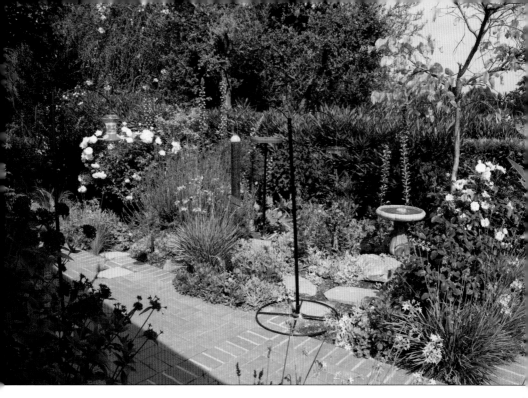

Birdfeeders in Los Angeles, main garden

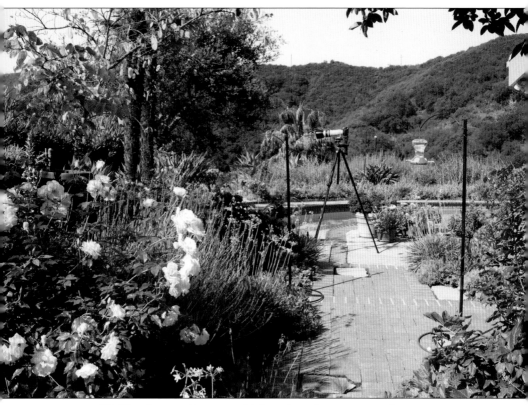

Birdfeeders and camera in Los Angeles, canyon view

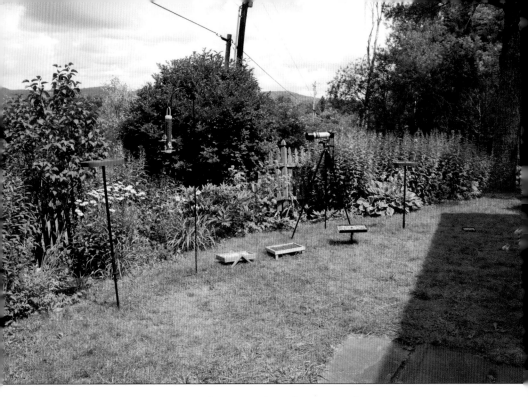

Birdfeeders and camera in Adamant, afternoon area

feeder, and the birdbath. Looking out from the garden toward the canyon, from left to right, in the bottom photo on the previous page: green platform feeder above the plants; hummingbird feeder; Canon EOS 7D camera body with a Canon 100–400mm lens; Nyjer feeder in the background across the pool; and the oriole feeder. The birdbath is hidden behind the flowers at left.

By observing the feeding habits of the birds in your garden, you will determine which types of food each bird chooses. Be ready for some surprises, however. For instance, I was convinced that the only bird that collected my unshelled peanuts was the Scrub Jay, but after a few days of testing the birds by only putting the peanuts on the platform feeder, I discovered that the California Towhee, California Thrasher, Spotted Towhee, and even the Golden-crowned Sparrow will grab an unshelled peanut and fly, or rather, drop off of the platform feeder, as these species tend to do. It seems as if the weight of the peanut is too much for them, or their grip isn't as strong as the Scrub Jay's, but take the peanut they will. Although most species eat all of the mixed birdseed, the Oak Titmouse flies onto the feeder and just

picks out a black oil sunflower seed, then flies into a tree to consume his food. A few minutes later, he's back to collect another sunflower seed, choosing not to linger on the feeder as a House Finch or a sparrow will do. So you have to be quick to get a photograph of that titmouse.

If I put black oil sunflower seeds in my platform feeder in Los Angeles, I am sure to attract a group of Nanday Parakeets. Sometimes, as many as seven or eight of these bright green birds will land on the platform feeder. The parakeets will eat mixed birdseed as well, usually in a group of two or three, but the sunflower seeds often attract a flock to the feeder. The best way to get a good photograph of a group of parakeets, or any birds for that matter, is to focus on one of the members of the group and then try to catch the other birds while they are not moving. This way, you can get most, if not all of the birds in focus.

Perhaps just as important as your plantings and your birdfeeders for attracting birds to your garden is a birdbath. Birds need water

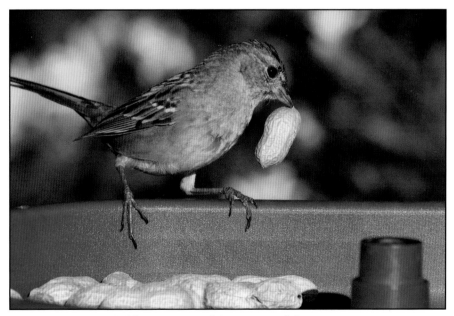

Golden-crowned Sparrow with peanut

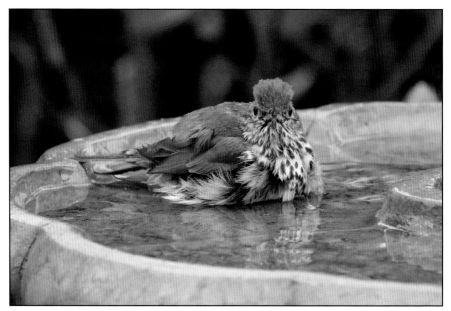

Hermit Thrush at birdbath

to drink and for bathing, and the birdbath setting offers some great opportunities for bird photography. Birds will often take a long time in the bathing process, so you may have plenty of chances to get a shot with the water flying about as the bird flaps his wings during his bath. Other times, the bird will perch on the side of the birdbath or stand in the water.

The birdbath also presents the happy circumstance of photographing birds that do not actually feed in your yard, or rare species that are just passing through and see the water in the birdbath as a refuge. In my garden, the only time I have seen the Western Tanager was one August day, and he was at the birdbath. Fortunately, I was quick enough to get a photograph of this colorful bird before he flew off.

The Yellow-rumped Warbler spends the fall and winter in my neighborhood, primarily feeding on the sumac bushes that grow down the hill from me on the canyon side of my yard. While these birds do not feed on anything in my garden, they make almost daily visits to my birdbath, often waiting for the Scrub Jays and Lesser

Goldfinches to finish up before they fly in for a quick drink, then back down the hill to the sumac.

The Hermit Thrush has similar habits, appearing at the birdbath when you least expect it. Like the Yellow-rumped Warbler, he does not feed in my yard, as he spends the winter eating the pyracantha berries at the house across the street from me. However, he uses my birdbath on a regular basis for drinking and bathing. The American Robin also feeds on the pyracantha berries across the street, but this bird arrives at my birdbath every day at about 7:00 a.m. during the winter, usually three or four individuals at a time. They drink and bathe and chatter at each other, then fly off. At this hour, there is very little light for good photography, but I have managed to get a few shots of these robins in the early morning. One day, however, I was lucky and a robin visited the birdbath in the afternoon, with the sun shining directly on him. Of course, my regulars such as the Scrub Jay, California Towhee, Song Sparrow, California Thrasher, Lesser Goldfinch, and Hooded Oriole (when he is here) visit the birdbath every day and throughout the day.

It is important to keep the water in the birdbath fresh. I use a brush every day to clean off the concrete and I use my hose to provide cold water on the birdbath a few times each day. This is especially important during the summer months, when the air is hot and dry and the birdbath may be the most popular spot in the neighborhood for an assortment of birds. Every now and then, in order to get the birdbath really clean, I pour a mixture of one part white distilled vinegar to nine parts water into the birdbath and let it soak for about fifteen minutes. Then I scrub off the surface with a small brush and rinse the birdbath out with water from the hose, then fill the birdbath up with fresh water.

Once you have selected your birdfeeders and your birdbath, you have to determine where in your garden to place them. Photography is all about the light, so the placement of your birdfeeders and birdbath should correspond with where the light in your garden is optimal for photography. In my Los Angeles garden, the light is best in the afternoon, so you can usually find me photographing there every afternoon that the sun is out from spring to fall, and less often in the winter because the days are so much shorter and the angle of the sun is much

lower in the sky and produces a harsher light than at other times of the year. During spring through fall in my yard, the foliage or flowers of the plants have enough light on them so that the background in the photographs will not be too dark. In addition, I will have the best chance of having the sunlight shining directly on my subject, giving me enough light to increase my depth of field and get as much of the bird into focus as I can.

In my Vermont garden in the summer, I have the sun shining into one portion or another of the garden from early in the morning until late in the afternoon. I decided to use one side of the yard in the morning for my hummingbird photography, and the other side of the yard in the afternoon for my photographs of seed-eating birds at platform and tube feeders. This is good for the hummingbird photography, because when a hummingbird becomes accustomed to a feeder being in a certain place, that hummingbird will tend to return to that feeder more often than when you change the location of the feeder all the time. Also, the more times the hummingbird sees you in a particular location, the more he will become accustomed to your presence in that

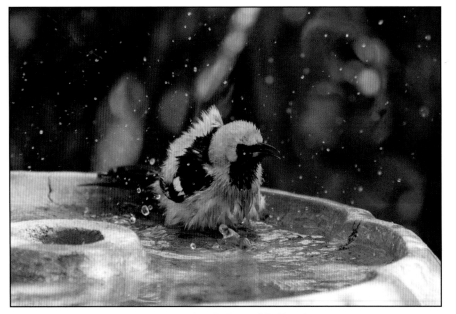

Hooded Oriole at birdbath

area and will become more relaxed having you in close proximity to his feeding area.

Wherever your bird garden is located, the light is generally better in the morning or afternoon than when the sun is directly overhead. You want to be careful not to photograph when the light is too bright and harsh, or when there is not enough light. However, no rules are absolute, as sometimes photographs of birds taken on lightly cloudy days (with the clouds acting as a filter) or even in a shady area, can bring out more warmth of colors than when the sun is shining brightly on the subject. You can experiment with different lighting conditions and determine which suits your style the best.

The time of year affects the angle of the sun in your garden, so you must adapt your photography to where the sun appears in the sky. In my Los Angeles garden, the sun sets farther to the west in the summer and stays above the mountains across the canyon longer in the day. This allows me to photograph later in the day and have the sunlight on my hummingbird feeder, oriole feeder, or platform feeder. In the winter, the sun sets earlier and shines into the yard at an angle that makes it difficult to use the bush daisy or oleander bush as a background, as they go into the shade. Winter is a good time in my yard to use the ground feeder or a platform feeder placed on the patio, as I have the winter sparrows to photograph. In general, however, I don't do nearly as much bird photography in the winter in Los Angeles as I do in the spring, summer, and fall.

In Vermont, during the summer, the sun shines even longer during the day than in Los Angeles, as I am so far north, but in the winter, the sun disappears behind the trees at around midday, so I basically only have the morning hours to photograph.

The changing angle of the sun throughout the year reinforces the concept that you must seize the day as a bird photographer. Take advantage of what the garden has to offer when it's available. You may not get a second chance. But if you remain observant and ready to spring into action, you'll have a very good opportunity of taking some excellent bird photographs in your yard. Having some good plantings, birdfeeders, and a birdbath in your yard will only increase your odds of getting that great bird photograph.

Hooded Oriole on pole

3

Camera Equipment

"Was I thirteen years old or fourteen when I got my first camera? I am not sure."

—Roger Tory Peterson,
"Seventy Years Behind the Camera"

A wide assortment of cameras and lenses can be used in bird photography, but in the end you will probably require only one or two lenses to take care of most of your needs. Most important, you need to have at least a 400mm telephoto lens, as birds are a lot smaller than you may think when it comes to photographing them.

I began my bird photography back in the film days with a Honeywell Pentax Spotmatic SP500 camera and a Tamron 80–210mm lens. In the spring of 1997, I had been asked by my publisher to produce a book entitled *Backyard Birdfeeding for Beginners*, including twenty photographs, and I spent many months in my Los Angeles garden photographing the Scrub Jay, House Finch, California Towhee, and Hooded Oriole, among other birds. I held the camera in my hand and approached the birds very carefully. Thinking back on it now, I am amazed that I got anything of value out of that arrangement, but a few of the thousands of color slides that I took still hold up today. One, of which I am particularly fond, shows a female House Finch standing atop one of the cornmeal and peanut butter patties I had made as an experiment to see which cornmeal mixtures would appeal to the birds the most. The way this bird tilts her head back with delight after consuming a few bites of this mixture humanizes the bird in a special way.

Another of the color slides I took while working on this book shows a Scrub Jay standing beside what began as 100 unshelled, unsalted, roasted peanuts on top of a rectangle of mixed birdseed that I spread on the grassy area of my yard. The Scrub Jay is looking at the peanuts, trying to figure out which one to pick up. I am still using this same birdbath in the yard, although it looks a bit worse for wear, and the grass has been replaced by a brick patio and a bed of plants. In another slide, I had moved in to just under ten feet away from the Hooded Oriole, and I held myself perfectly still until he came up to the oriole feeder, which I had hung in the lemon tree. (The lemon tree is long gone.) In January of 1998, I was still working on my book and I took a photograph of an escaped caged bird called an Orange-cheeked Waxbill that was perched on my red platform feeder, with the husk of a millet seed falling from his beak. This bird had appeared in my yard the previous July 27, and he had been hanging out with a flock of House Finches ever since. I was fortunate to get this rare photograph when I could, because my final record of the waxbill in my yard was on February 2 of that year.

As it turned out, the publisher decided not to use photographs for my birdfeeding book, which was a difficult pill for me to swallow, but it actually motivated me to take more bird photographs, just to "show them." In 2002, I purchased a Tamron 200–500mm lens to use with my Pentax camera body, and about a year later my photographs came to the attention of the National Geographic, which gave me a column on their website entitled "The Birdman of Bel Air," featuring my bird photographs and essays about my experiences with birds, not only in my backyard but in national parks and other locations.

In 2004, I went digital, purchasing a Canon EOS 300D Digital Rebel camera, along with a Canon 18–55mm lens, a Tamron 200-400mm telephoto lens, a Tamron 28–300mm lens, and a Canon Speedlite 430EX external flash. For the next eight years, I used this camera, taking thousands of bird photographs both in my yard and in locations as diverse as the Galapagos, the rain and cloud forests of Ecuador, my garden in Vermont, and various natural areas in California.

Finally, in 2008, an exhibition of my bird photographs appeared at at the James Gray Gallery at Bergamot Station in Santa Monica, California. All of the photographs in that show were taken with my Digital Rebel and the lenses I mentioned. After this show, I continued to take bird photographs with the Digital Rebel and sometimes with its successor, the EOS Rebel XSi, and I added to my arsenal a Tamron 180mm macro lens specifically for photographing close-up shots of hummingbirds. But eventually, I realized that I had to upgrade my equipment again, so in 2012 I purchased a Canon EOS 7D camera, along with a Canon 18–135mm lens, a Canon 100–400mm lens, a Canon 50mm macro lens, a Tamron 10–24mm lens, and a Canon Speedlite 600EX-RT external flash.

This is the equipment that I use as of this writing, and all of the bird photographs in this book were taken with the Canon EOS 7D camera body and either the Canon 100–400mm lens, Canon 50mm lens, Canon 18–135 lens, or the Tamron 180mm lens with a Tamron 1.4x teleconverter attached to it. This equipment has served me well, but the 100–400mm lens does have some limitations. For instance, the lens is designed to be used in autofocus, which means pressing down lightly on the shutter button until a specific autofocus (AF) point in the viewfinder recognizes the bird's eye and brings it into focus. But if the bird moves, you often have to use a different AF point in the viewfinder and recompose the shot quickly enough to get the eye in focus again. Without the eye in focus, virtually all bird photographs are essentially worthless. For a few months after I purchased this lens, I also used manual focus and I had some good results with it, especially with the Ruby-throated Hummingbird in Vermont, but now I almost always defer to autofocus set in AI Servo mode (usually used for tracking moving objects) and Spot AF as the autofocus area select mode, which I normally set on the bird's eye, or as close to the eye as possible. This allows the camera to continually focus on the bird as the bird's tiny movements, even when perched, are tracked by the camera's focusing mechanism.

Another problem is that there are not enough of these AF points in the viewfinder to cover the edges at the top and bottom of the frame, so I miss a lot of opportunities to get the shot I want right out of the

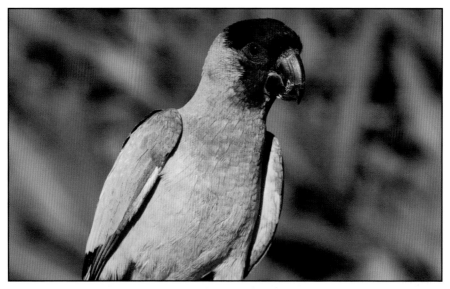

Nanday Parakeet

camera and I have to crop the image to reframe the bird so that it is not high or low or to one side or the other in the frame. In addition, the autofocus feature on this lens will not work with a teleconverter, so I use the lens mostly at 400mm and I crop the image if I want to make the bird appear larger. This is far preferable, however, than using a 1.4x teleconverter and manual focus. First of all, the teleconverter degrades the image compared to using the lens by itself, and manually focusing through a teleconverter is even more difficult than without one. Despite these drawbacks, I have managed to get some beautiful bird photographs using this lens.

While using a zoom lens may not give you as sharp an image as a fixed lens, it does give you the flexibility to zoom in and out to reframe an image and get a different feel to your shot. For instance, let's say I'm photographing a Nanday Parakeet at my platform feeder, and suddenly a group of parakeets flies onto the feeder. After getting my close shots of the first parakeet at 400mm, I can zoom back to 150mm and capture the group of parakeets.

On another occasion, after photographing a close-up of the Hooded Oriole on the canyon side of my yard, with the lens set at 400mm from about nine feet away, I zoomed out to 100mm in order to

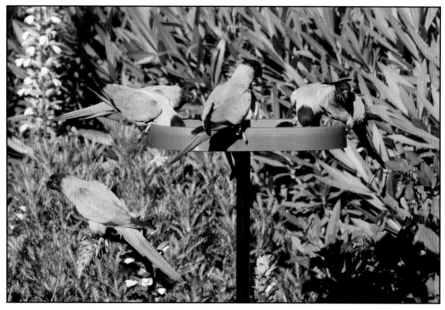

Nanday Parakeets

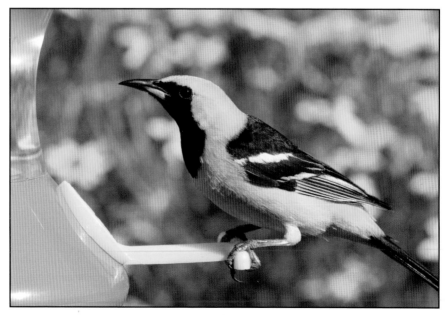

Hooded Oriole and Mexican marigold

capture the bird with more of his environment around him in order to tell a wider story. While the size of the bird in the frame is smaller, the photograph is evocative because it shows the Mexican marigold flowers behind him and the trees beyond that, while the bird is perching on the pole, just about to jump over to the oriole feeder and a drink of sugar water. This juxtaposition between nature and the suburban comforts of home, while highlighting just how small the oriole actually is in the overall scheme of things, gives this image its emotional impact. Without the zoom capability, I would have had to move back at least fifteen feet from the bird and he would have flown off as I moved back. Also, when you photograph from a longer distance from your subject, focusing does not work as reliably, so I would rather use a smaller telephoto setting from closer range than a longer telephoto setting from longer range. Since I am photographing birds in my garden that are familiar with me and allow me to take their pictures from close range, I take full advantage of this proximity in order to make my images as clear and in focus as possible.

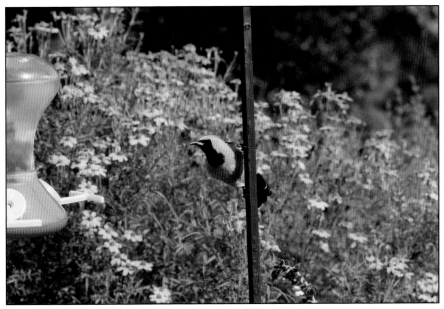

Hooded Oriole on pole

Pulling back on the zoom also gives me a chance to photograph the Hooded Oriole and other birds in flight. One day, after photographing the Hooded Oriole at 400mm, I pulled the zoom back to 100mm and positioned the oriole feeder on the left side of the frame, giving the oriole plenty of room to fly into the right side of the frame. I bumped the ISO way up to 6400 ISO, and took the shot at 1/8000 second at f/8, in shutter priority. I used autofocus on the bird, and just when I thought the bird would fly off, I pressed down on the shutter in high-speed continuous mode.

Perhaps the most desirable feature of a 100–400mm lens for me is that I can focus to within six feet of the bird, whereas a fixed 400mm lens would not focus that close, thus making the bird appear smaller and perhaps causing me to need a teleconverter, which I only use now with my 180mm macro lens when photographing close-up shots of the hummingbirds.

I use the 180mm lens with a 1.4x teleconverter in order to focus from four feet away from a hovering hummingbird, and at this distance the tiny object fills up the frame. The error rate is very high as

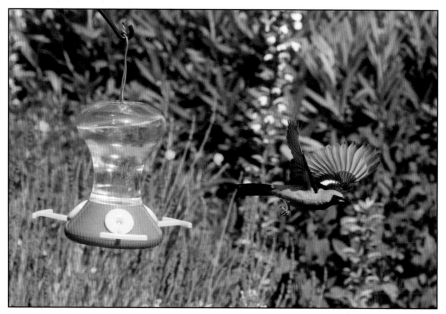

Hooded Oriole flying off from feeder

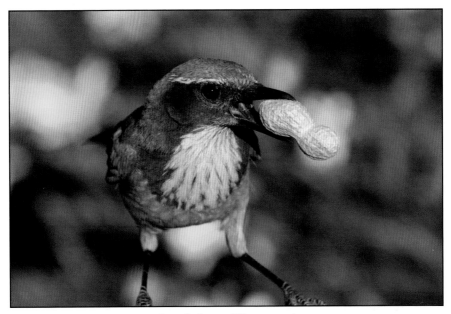

Scrub Jay with peanut

many shots show just half of the body or are out of focus because the depth of field is so small, but the few pictures that do work make it all worthwhile. Besides, I love the excitement of having a hummingbird fly into the frame at such close range. First, you hear the humming of his wings, and suddenly he is in the frame of the shot. You almost trip over yourself with the anticipation of what you are going to get, so you have to remember to concentrate and get the shot before you celebrate.

While I use a telephoto lens for almost all of my bird photography, there are times when smaller lenses come in handy. For example, in order to capture the Scrub Jay in flight (especially with a peanut in his beak), I often use my 18–135mm lens, handheld and set at autofocus with the AF point at the edge of the feeder. Using shutter priority set to at least 1/1600 second and using at least f/7.1, I have a pretty good chance of getting the flying bird in focus. In this case, I use the high-speed continuous shooting mode, so I end up with a series of images showing the jay farther and farther away from the feeder. I usually pick the first couple of shots in this series, as this shows the

Scrub Jay flying off ground platform feeder

bird as a larger object in the frame. The challenge here is timing the pressing of the shutter button to exactly when the bird flies off of the feeder. This technique is very useful for photographing the Scrub Jay flying off of the ground platform feeder that I place on my patio, as well as for when these birds fly off of the green platform feeder placed on a pole.

Similarly, I used the 28–300mm lens attached to the Digital Rebel camera body in July of 2005 in order to photograph the Scrub Jays taking peanuts from this green platform feeder and flying off with them. It was part of a project I did in which I placed various types of food items on the feeder for the jays, and although I got some photographs of the jays flying off with such things as cashews, almonds, and Goldfish crackers, the shots of the birds flying off with the peanuts in their beaks are the most satisfying to me. I set the camera on shutter priority with the shutter speed at 1/2000 second, 1/3200 second, and even 1/4000 second and focused on a spot just off of the feeder in the direction that I expected the bird to fly.

In July of 2004, the 28–300mm lens paid off when I photographed an Allen's Hummingbird in flight as she rose off the oriole feeder after drinking the sugar water there. I set the camera on shutter priority at 1/3200 second and captured a really neat image of this bird, which has been published in numerous field guides. Fortunately, the sun was shining brightly enough that I could take the photograph at only 800 ISO, so the image is of a high quality.

I have used two small lenses to photograph hummingbird nests, neither of which were in my yard. In the first instance, I was given a tip on an Allen's Hummingbird nest that had been built on the stem of a bush right outside the front door of the apartment of a friend who lived in Santa Monica. It was March of 2004, just days after I had purchased my Digital Rebel, and off I went every morning to photograph this hummingbird nest, which contained a female and two eggs, only one of which hatched. I followed the progress of this little hatchling from the day he came into the world until he flew out of the nest for the first time several weeks later.

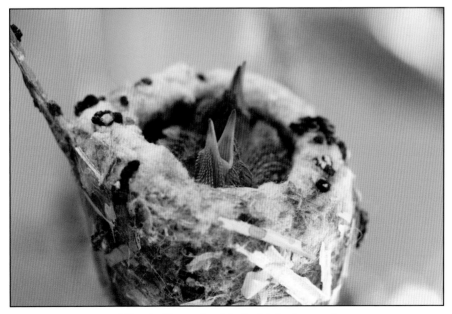

Allen's Hummingbird chicks in nest

During this shoot, I used my 18–55mm lens with a built-in flash in order to shoot down on the nest as I was standing on a stool. One of my favorite images was taken when the chick was only one day old, and you can see his tiny beak opened wide in anticipation of being fed by his mother. Nine days later, I took another photograph of this bird with the 28–300mm lens and the built-in flash, this time a profile as the chick raised his head up out of the nest to search for his mother and the food she would be bringing.

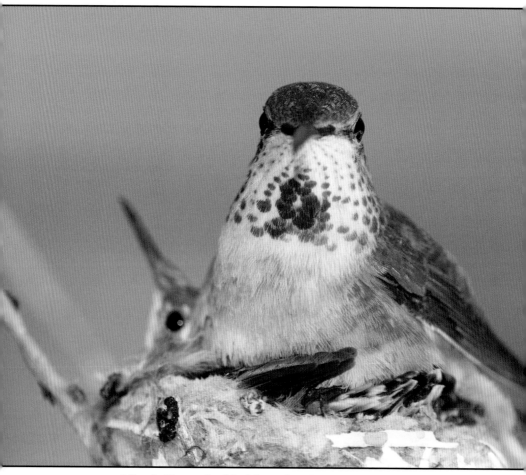

Allen's Hummingbird female with chicks in nest

Eight years later, I received a call from the San Fernando Valley Audubon Society, of which I served on the board of directors. One of our members had an Allen's Hummingbird nest that had been constructed on a hanging mobile on her back patio in Sherman Oaks, California, and she wanted someone to photograph the female and her chick. During the next six weeks, I photographed this chick until it fledged, and along with it a second brood that this hummingbird had, consisting of two chicks. From about one foot away, I used my 50mm macro lens attached to my 7D camera body, along with a Canon Speedlite 600EX-RT external flash, to get close shots of the humming- bird chicks in the nest. In order to do this, I climbed up onto a small ladder, held on to the rim of the mobile with my left hand to stabilize the

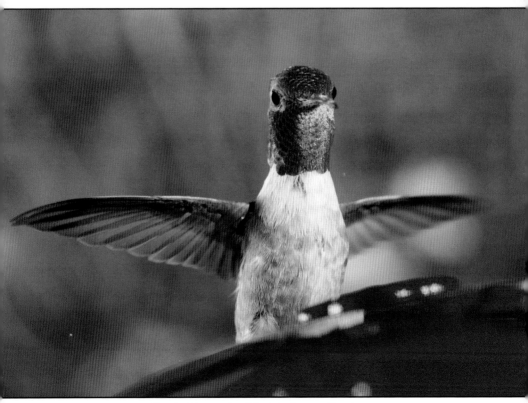

Allen's Hummingbird using reflector

nest, and held the camera in my right hand and clicked away, using autofocus on these little birds. While hundreds of shots were out of focus, I succeeded with a few and the results were very rewarding.

For longer shots of this hummingbird mother and her chicks, I used my 180mm macro lens and a 1.4x teleconverter attached to the Rebel XSi with the Speedlite 430EX for the first chick, and then attached to the 7D camera body with the Speedlite 600EX-RT, which I had just purchased, for the second brood. Shooting from about six feet away, I had to take many photographs with different levels of flash brightness in order to get the exposure correct in this environment, which was in the shade and included a turquoise wall in the

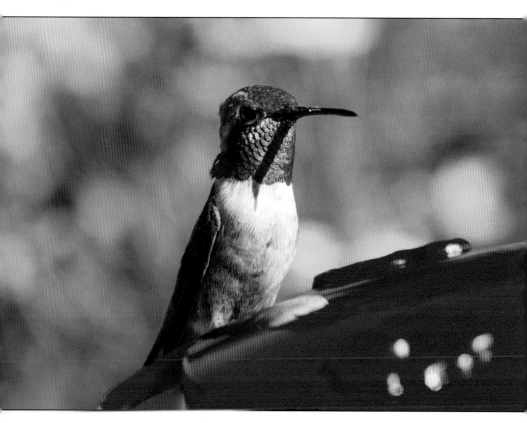

Allen's Hummingbird without using reflector

background. One particularly special image shows the mother hummingbird sitting on top of her chicks, which were to fly off the nest only three days later. Believe it or not, hidden behind the mother in this photograph is another chick sitting in the nest. Both of the chicks have just been fed. It is images like this that make backyard bird photography so rewarding, as the camera reveals the intimate details of birds' lives that are not visible to the naked eye or the casual observer.

As far as teleconverters are concerned, if you are going to use one, I suggest using a 1.4x as opposed to the 2x teleconverter. Although I used a 2x for a number of years with my Digital Rebel and my Tamron 200–400mm lens, I finally had to admit that while this teleconverter made the bird larger in the frame than the 1.4x, the resulting loss of quality in the image and the inability to focus with any degree of surety, because of the small depth of field, made me switch to the 1.4x. For a few years, I used the 1.4x with my Tamron 200–400mm lens mounted on my Digital Rebel for photographing songbirds, as well as with the 180mm macro lens for shooting the hummingbirds up-close. Keep in mind that a teleconverter reduces the amount of light that hits your sensor, because the light has to travel through more glass. So you may have to increase the ISO settings in order to get shutter speeds and f-stops that are comparable when you are photographing without a teleconverter.

I used an extension tube a number of times with the Digital Rebel and my 200–400mm lens, and it allowed me to focus as close as six feet away from the Anna's and Allen's Hummingbirds, as opposed to the eight-foot distance that the lens required without the extension tube. In one shot, I aimed the camera to a spot just above the hummingbird feeder, where I knew the Anna's Hummingbird would fly after he had taken some nectar. Looking through the frame and anticipating when the hummingbird would fly up into that area, I clicked at just the right time, also positioning the bird between two clusters of red fuchsia flowers. About ten minutes later, I did the same thing with the Allen's Hummingbird, as the red fuchsia flowers complemented the hummingbird's red gorget (throat). I

took both photographs in manual mode at 1/2000 second and f/8, and the ISO at 1600.

On one occasion with my Digital Rebel, in my desperation to get closer to the birds with my somewhat primitive equipment, I "stacked" the extension tube along with the 1.4x teleconverter on the 200–400mm lens in order to obtain a close shot of a Black-chinned Hummingbird at the hummingbird feeder, in which the bird would appear larger in the frame than without using the extension tube. I did this because I could focus the lens two feet closer to the bird than I could with just the lens and the teleconverter. The Black-chinned Hummingbird visits my yard every spring and summer, and both the male and female use my hummingbird feeder. However, the male is extremely wary and even a hint of your presence will send him flying out of the yard. One day in June of 2007, I kept myself perfectly still as the male perched on the feeder while I was only about six feet away. In this case, the bird remained on the feeder for about thirty seconds, and I was able to get a nice shot of him as his wings extended outward. This pose was made possible because, for some reason, the bird didn't fly off even though he heard the click of the camera's shutter.

During the period when I used the Digital Rebel, I considered myself something of a purist and was not interested in cropping in order to enlarge an image. Instead I tried to get everything "in the camera," and I sacrificed some quality using this approach as I was forced to use higher ISO settings in order to get the shutter speed and f-stop high enough to freeze my subject and give me enough depth of field to keep the bird's entire body in focus. I also did not have the computer hardware and software necessary to do a good post-production job with my images, nor was I interested in doing so.

But when I purchased my Canon EOS 7D camera body, I upgraded my computer system with a 15-inch Apple Macbook Pro with Retina display, along with Adobe Photoshop CS6. I set about learning this program, and now I can crop, lighten, darken, and perform other editing tasks on my digital photographs that I was unable

to do before. But that was then, this is now. At that time, I was doing the best that I could with the equipment that I had.

In addition, when I was using my Digital Rebel, I was shooting JPEGs, as opposed to shooting in RAW image files, which is what I do now. It is far more difficult to do image editing with JPEG images than with RAW images, and I encourage you to start photographing in RAW. These images contain much more information than JPEGs, and this data can be used by the software to make your photographs look as good as possible.

As I explained above, an external flash or built-in flash (if you don't have the external flash with you) is useful for photographing hummingbirds in the nest, especially if the nest is in a shady area. However, your flash unit can also be used to provide "fill flash," when a bird on an otherwise sunny day happens to be in the shade or when the sky is overcast. This technique will highlight some of the colors on the bird's body that would not ordinarily be visible and will bring out more of the bird's face, as opposed to a shadowy, dark image. I rarely use this technique, but many bird photographers use fill flash on a regular basis.

Another way to get more light onto your subject is to use a reflector. Normally used for portrait photography, reflectors bounce light from the sun back onto a portion of your subject that is in the shade if the sun is coming from the opposite direction. On the canyon side of my yard, there is no room to get the afternoon sun directly behind me, as the narrow bed of flowers is perched on the side of a steep hill. Therefore, as an experiment, I set up a silver reflector on a tall stand and reflected the sunlight back onto the hummingbird feeder. This caused the right side of the Allen's Hummingbird's face as well as his body to be well-lit instead of being in a shadow, enabling me to capture more of the hummingbird's bright-orange gorget. (If you are not using a reflector, these dark areas can be lightened up in image editing.)

As far as filters are concerned, I use a UV filter with my lenses, which serves two purposes. First, it filters out ultraviolet rays that

can make photographs hazy, and second, it protects the lens. This came in handy in Vermont when I tripped while photographing an American Robin nest in a tree at the local co-op and fell forward onto the ground. Fortunately, I was not injured, but the UV filter on my 18–135mm lens was scratched by the soil as the camera hit the ground before I did, helping to break my fall. Replacing the filter was much easier than replacing the lens.

Having a good, steady tripod is essential for successful bird photography. Birds are moving all the time, so the more stable my camera is, the better chance I will have to get a bird photograph that is in focus. I also have two batteries per camera body, as I never know when a battery will run out, and I always have a lens cloth nearby in case I need to clean off the lens.

A cable release is not necessary for bird photography, as I really need to focus through the viewfinder with my hand on the camera since the bird is moving around so much. But a wireless remote is useful for taking videos of birds with the 7D camera body as it allows me to start the camera without having to press the button on the back of the camera. I often use an LCD screen loupe as well, which allows me to look at the LCD screen on the back of the camera without the glare of the sun.

I find it very useful to keep field notes of my bird photography activities. I write down such things as the species of birds that I see, their interesting behavior, and such information as which lenses I use, my distance from the birds, and the camera settings. Later, I consult these field notes to determine which techniques work best for my bird photography, and even years later I can refer to these notes to remember what I did on a particular day of shooting. These field notes are especially valuable when I am on a field trip, or when I am on an extended stay in another location, such as Vermont. I use ruled, gummed paper pads for my field notes, and I fold the paper into quarters and write on the left column, then the right column on each page, then turn the page over and start again. Later, I unfold these pages and put them into file folders for each year.

Now that you have your equipment in place, it is time to get out in your garden and take some great bird photographs. Don't forget to protect yourself from the sun by wearing sunscreen and using a wide-brimmed hat. Also, have a bottle of water nearby. You may be out there for a while.

Allen's Hummingbird

Getting Close
To The Birds

"One who observes birds at a distance through binoculars as they flit through the trees has many a thrill as he makes new acquaintances or hears new songs. But the one who watches them for hours at arm's length, at the nest or even at a feeding station, acquires a fund of understanding of bird life and bird instincts that can be gained in no other way."
—Arthur A. Allen, *Stalking Birds with Color Camera*

It is said that you can get close to the birds in the Galapagos, and for the most part this is true. The birds will just stand there if you walk up right next to them. But if you play your cards right, you can have a Galapagos in your own backyard, where the birds will be so familiar with you that they will let you get as close to them as the birds in the Galapagos do.

In the first place, having a constant source of food available for the birds will endear them to you. I have a policy, especially with the Scrub Jays, but also with the California Towhee, Song Sparrow, and the other birds, that I give them some food when I make an appearance in the garden. I am fully conscious that these are wild animals, and their time for food gathering is as important to them as our time for seeing to our survival needs is to us. Therefore, I do not want to waste even a minute of their time when it comes to foraging for food. I think the birds are aware of this effort, and they reward me for it.

Now, let's say the Scrub Jay is perched in the avocado tree and he sees me walk into the garden, perhaps to refill the hummingbird feeder or to position my oriole feeder in just the right spot. If the plat-

form feeder is empty, I will not return to the house and leave the feeder empty. I will bring out some birdseed in a cup and make a little show out of pouring the birdseed onto the platform feeder. I may even bring out a few unshelled, unsalted, roasted peanuts and throw them one by one onto the patio.

"Come get your peanut," I'll say to the jay, who is bobbing his head up and down to get a better look at his surroundings. Finally, he can't resist it anymore and he flies down to the orchid tree for a closer view of the peanut. Pausing momentarily, he then drops down to the patio, walks a few steps over to the peanut, looking up at me as he gets closer to his treat, and then his beak grabs the object. With a quick glance up at me to make sure everything is OK, he takes to the air with the peanut, sometimes squawking as he flies off.

He is obviously a very happy Scrub Jay, and this activity attracts other Scrub Jays to the yard. In fact, all of the activity in the yard feeds on itself. When the House Finches discover a platform feeder filled with mixed birdseed, their little cheeps get the attention of other birds in the neighborhood, such as the Song Sparrow, Mourning Dove, and Spotted Towhee. So in your garden, as the birds discover that they can feed in safety along with other species, they become more prone to visiting and lingering on a daily basis. Over time, your garden will become their home.

This is especially true in my yard with the California Towhee. A nondescript, brown bird, the towhee waits outside the sliding glass door to my patio at any time of the day to make sure that he gets fed, and he often comes out of the bushes and starts peeping as soon as I walk through the door onto the patio. As I walk over to the feeder with the mixed birdseed, he follows me (emitting his high-pitched peeps along the way), first by hopping a few steps, then flying onto the birdbath, then dropping down into the plants, and then reappearing on the feeder as I move back after leaving the birdseed on it.

On numerous occasions, the towhee has hopped into my TV room in search of birdseed, when I have left the sliding glass door open and the platform feeder is empty. I have to shoo him outside when he catches me by surprise like this. You see, he knows that I keep the birdseed in a plastic bin just inside the door, along with my bags of

peanuts and other food items and supplies for my backyard bird photography.

My relationship with the California Towhee and peanuts is quite extraordinary. Unlike the Scrub Jays, which are happy to take an unshelled peanut, the towhee likes to be "spoon-fed" his peanuts, one-half kernel at a time. (Most of the time, I think he is waiting for a peanut, and not the birdseed.) As he stands below me, I open an unshelled peanut and drop half a kernel onto the patio. The towhee picks the kernel up in his beak and flies or runs off to the shrubbery to eat the peanut in safety. On many occasions, he sees me from across the pool and flies over to position himself at my feet. After I give him his peanut, he flies back across the pool to the exact spot from which he flew over to me. Believe me, this towhee knows what he is doing.

Similarly, the Song Sparrow, which in the wild is a shy, reclusive species, has become relatively tame in my garden. In the spring, the individual in my yard often flies up to the picture window in my TV room, which looks out at the main part of the garden, and he makes a soft sound when his feet hit the sill. This alerts me to his presence.

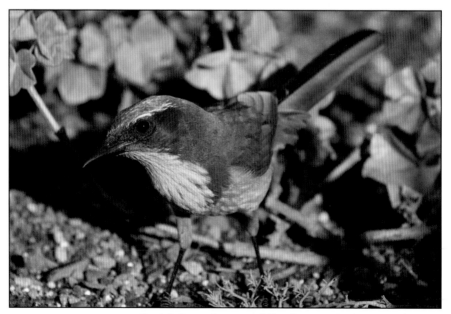

Scrub Jay at ground feeder

Then he lets out a song, which you would usually hear by a streambed when walking through the woods. He often emits this call while he is perched on a plant or on the edge of a flower pot just outside of the picture window. He is more than likely seeing his reflection in the window and thinks it's a rival. But I like to think that he is calling for me.

"Bring out the birdseed," he says, hopping to a nearby bush. "Bring out the birdseed."

So I go outside with a cup of birdseed. The Song Sparrow flies over to the oleander and waits underneath it while I sprinkle some bird-seed on the ground. Then he hops over to this patch of dirt and starts eating, along with the California Towhee and the Golden-crowned Sparrow, right at my feet. I leave the rest of the birdseed on the plat-form feeder and go back inside, knowing that I will not be disturbed by the Song Sparrow for a while.

Whichever birds you have in your garden, and wherever you live, this principle will apply: be attuned to the needs of the birds in your garden. They will respond to you if you provide for them. But once you have the birds in your yard, you still have to get close enough to them to take a great bird photograph. There are two ways to get close to birds: move toward the bird, or remain in one place and let the bird come to you.

From the bird's point of view, any object moving directly toward the bird is perceived as a threat—and rightly so. Therefore, if you are going to approach a bird, the least threatening way is to move in a tangential fashion, getting closer and closer gradually. Sometimes, when I am out in the field, I will actually walk off to one side of the bird or the other, as if I am moving off entirely, and then I'll stop, wait a few moments, and then start to angle my way back in the opposite direction, just a few feet closer to the bird this time. These fieldwork movements can be compressed in your yard so that you only move a few steps in either direction. The point is to work your way closer to a bird little by little, so that the bird gets used to your presence and does not see you as a threat.

One of the most important rules of bird photography (and one that I break from time to time) is to take the first photograph you

have in any given opportunity, just in case your subject moves. This first photograph may be taken at some distance, but at least you have something. Then you can move in closer and try to get a better shot. Sometimes, in my anticipation of getting that close shot, I forget to take that first shot and as I move in, I scare the bird off and I lose any chance for an image at all. I usually kick myself for being so impatient and careless and I tell myself that it'll never happen again. But invariably, it does.

Another important factor is time. Let's say you have a bird that has just appeared in the yard for the first time, perhaps a Fox Sparrow, a skittish species. Tell yourself that you have a week, even a month, for this bird to get used to you and the camera. Take your first photographs from about fifteen to twenty feet away. The bird may not be scared off by your movements at this distance. Next time, try moving in another foot or so, and so on. You may find that you can photograph this bird from as close as seven feet eventually, but it will take some time to get in that close. By then, the bird has determined that you are no longer a threat, and as long as you do not make any sudden movements, you can photograph this bird at close range.

Keep in mind that the reflection of the glass in your lens can be seen by the birds and will make them fly off when you least expect it. So when you pan the camera back and forth on the tripod, make these movements slowly and smoothly. Similarly, with your hands, move your finger to the shutter button slowly. When I'm wearing my floppy hat, my fingers are actually under the front rim of the hat while I'm pressing the shutter, so the bird does not see this movement. When you are at very close range, these details can make the difference between getting a great bird photograph and watching your subject fly off before you have a chance to click the shutter.

If you stand over a bird, the bird will feel threatened and may fly away, but if you lower yourself down to his level and remain still, he will consider you as just another part of the environment and he will relax enough for you to get some good photographs. This is the case with my ground feeder in my garden in Los Angeles. I place a small pile of mixed birdseed on the soil by the side of my brick patio, and I wait for the birds to come in from the bushes and take the bird-

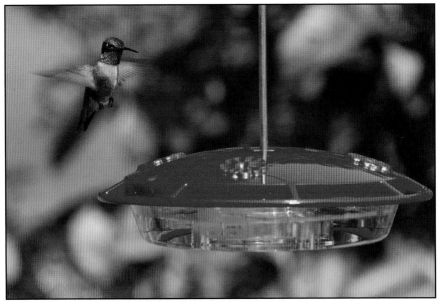

Ruby-throated Hummingbird and feeder

seed. (On many occasions, the birds that are eating this birdseed have hardly taken any notice of me as I photograph my camera setup while standing above them.) It's very gratifying to get so close to the place with the birds that they send you the message that it's OK with them that you're around. This means that they have gotten used to the reflection of the lens of the camera, and all of those clicking sounds they hear when the shutter goes off. They have determined that all of this confusion will not threaten their survival, so they relax and start eating. Any sudden movement, however, would send these birds scurrying back into the bushes.

Getting close to songbirds is one thing, but how do you get close enough to a hummingbird so that you can photograph him from three feet away? It's not easy, but it can be done.

As with the songbirds, you want to start your photography from farther away from the bird, perhaps ten to fifteen feet away. In Vermont, I used this technique with the Ruby-throated Hummingbird in the summer of 2012. I had not been in this garden since June of 2009, at which time I had only a few visits by the hummingbird to the feeder and, hence, only a few photographs.

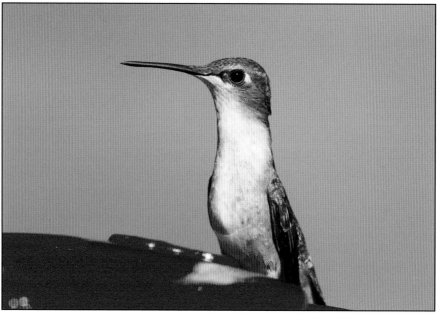

Ruby-throated Hummingbird

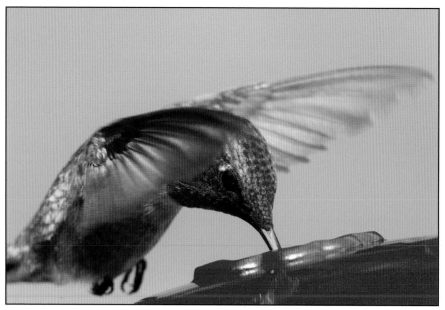

Ruby-throated Hummingbird hovering and drinking

I set up the feeder expecting to have a hard time attracting this hummingbird again, but to my surprise, a male and female began visiting the feeder the very first day I put the feeder up, and this went on for the next five weeks. I was beside myself with excitement, but I didn't want to scare them off by getting too close too soon. So I set up the camera with a 100–400mm lens, about fifteen feet away, and I just stood there . . . and stood there. Looking through the lens, I manually focused on one of the feeding holes on the feeder where I expected the hummingbird to go, so that if the hummingbird landed, I would have less focusing to do before I clicked the shutter. If the bird rose into the air, I would just pan up there with him, adjust the focus, and then click.

Sure enough, the male rose above the feeder and I panned up and got a nice shot of him hovering above the feeder. The following morning, I moved in to about ten feet away, and I discovered that the hummingbirds still came to the feeder. The day after that, I moved in to six feet away, and to my surprise, the female actually landed on

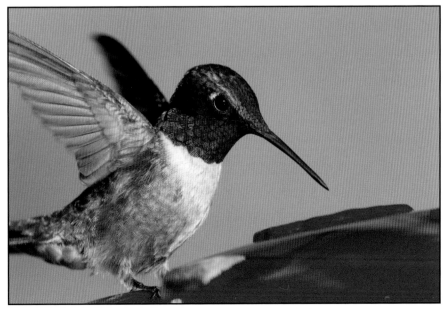

Ruby-throated Hummingbird

the feeder. I got a quick shot of her looking at me before she flew off. This time, the bird is noticeably larger in the frame than at ten feet, and for the next four days I continued to use the 100–400mm lens from six feet away with the hummingbirds, which is as close as this lens will focus.

While I was fond of the photographs that I took with the 100–400mm lens, I knew that I had to get closer. But would the humming-birds put up with me at such close range? I knew that the Allen's and Anna's Hummingbirds in Los Angeles would let me get less than three feet away when I took my head shots of them using the 180mm macro lens, but would the Ruby-throated Hummingbird be as accommodating? There was only one way to find out.

On July 9, I took my Tamron 180mm macro lens and a Tamron 1.4x teleconverter out of the camera bag and attached them to the 7D camera body, then placed the camera onto my tripod. I positioned myself just under four feet from the feeder, put my eye up to the eyepiece, pre-focused on the feeder hole where the hummingbird usually went, and waited . . . and waited. Ten to fifteen minutes went by, and no hummingbirds.

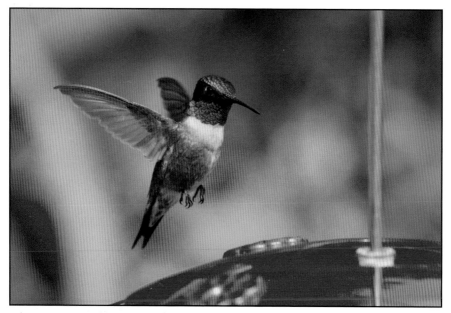

Ruby-throated Hummingbird hovering above feeder

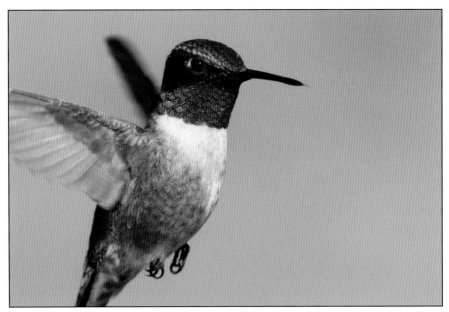

Ruby-throated Hummingbird

Suddenly, I heard a humming from afar, and the humming got closer and closer. Before I knew it, the hummingbird was in my viewfinder, drinking as he hovered. Since I was using manual focus, I turned the focal ring with my left hand as I clicked the shutter. I tried to time my shutter clicks for when the hummingbird had his beak in the feeder hole. He was too nervous to perch with me so close, and as it turned out, most of my photographs of this hummingbird are when he is hovering above the feeder, or when his beak is in the feeder hole while he is hovering. Nevertheless, I did manage to get a few macro shots of the male and female Ruby-throated Hummingbird while they were perched on the feeder.

The following day, I moved in to three feet away, but I discovered that I was actually too close to get enough of the hovering humming-bird in the frame and in focus to produce a satisfying photograph, so I moved back, first to 3¾ feet, and then back to four feet again, which became my comfort zone for this shoot. Just after I did this, the male landed on the feeder and began to drink. I focused, clicked,

and the sound of the clicking shutter caused the bird's wings to rise up toward the sky. A couple of hours later, the female landed on the feeder and I got a shot of her looking over at me from behind the hanging hook. It was interesting to see this little bird staring at me from across a piece of manmade equipment specially designed to provide her with food. The interface between man and nature was certainly achieved in this photograph. A couple of hours after that, I captured the male as he hovered above the feeder, with the pink roses in in the background.

Over the next couple of days, I continued to use the 180mm macro lens on these hummingbirds. There is nothing quite like looking through the viewfinder from this close range and seeing the subject of your photograph fill up the frame while he is looking at you and trying to determine if you are a threat to him or not. It makes the resulting photograph that much more rewarding to know that this tiny bird trusted me enough to let me get right up into his face for an intimate portrait.

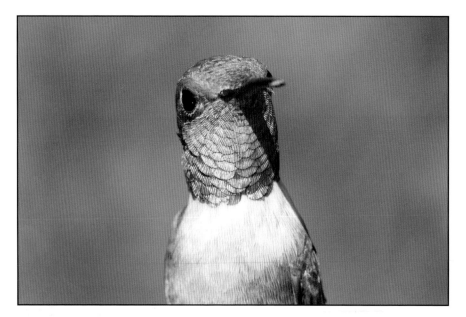

Allen's Hummingbird portrait

As I mentioned above, in Vermont I determined that the Ruby-throated Hummingbird would not perch long enough on the feeder when I was closer than four feet away in order for me to get a good head shot of him. Therefore, I deferred to longer-range shooting (i.e., four feet away), in order to capture as much of his body as I could in the shot and still have a macro photograph. While the error rate was quite high (I took a lot of shots with half of the body in the frame, or with some or all of the hummingbird blurred), the photographs that were successful make all of the extra shots I had to take all right with me.

But in Los Angeles, the Allen's and Anna's Hummingbirds allow me to stand less than three feet away from them while they perch on the feeder. In 2008 and 2009, I used this setup to create some beautiful portraits of these hummingbirds. I used the leaves of the bush daisy for a green background, its flowers for a yellow background, and the fuchsia flowers for a red background. In one instance, I placed the bird's head between the blurred yellow bush daisy flowers with the green foliage as the background in the middle of the frame. This was

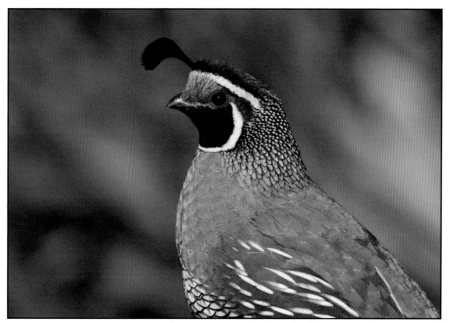

California Quail

not easy to do, as I had to predict where in the frame the humming-bird's head would be when he rose up from drinking the sugar water at the feeder. In another instance, I had to position the feeder so that the sun would refract off the crown (top of the head) and gorget of the Anna's Hummingbird in such a way that the magnificent purplish-red color of these feathers would be revealed.

The key to success in this situation is keeping perfectly still, with my eye looking through the eyepiece, before the hummingbird arrives. With my shutter finger hidden underneath my hat, the hummingbird detects virtually no movement from me, so that his only distraction will be the sound of the shutter each time I take a picture. Once he gets used to this sound he will perch with some degree of regularity (however brief those visits may be) and I can shoot away. This is not as easy as it sounds, but it can be done if you are very still and very patient. You may have to stand in one spot for a few hours or longer to get a ten-second visit from the hummingbird—and then you have to get the shot. But after all, that's part of the challenge of backyard bird photography.

I revisited this technique in the summer of 2013 in Los Angeles with the Allen's Hummingbird, using the 180mm macro lens and the 1.4x teleconverter, just as I had done years earlier. In this shoot, which took about a week, I started at four feet away from the hummingbird, and I managed to get a really neat portrait of him just as his head was turned toward me with an inquisitive look on his face. Over the next few days, I took a number of other macro photographs of this hum-mingbird, from 3¾ feet and even from as close as three feet away.

As you can see from these examples, while the technique of mov-ing gradually toward a bird can be successful for reducing the dis-tance between you and your subject, you can also stay in one place and let the birds come to you. This works not only with humming-birds, but with other species of birds.

For instance, the California Quail is an extremely wary species and he runs about as fast as he can fly. Try to get close to a quail by walking up to him. It's impossible. But many times I have been sitting on my stool photographing the ground-feeding birds in my

garden when, usually in the late afternoon, I'll hear from the bushes the familiar guttural call of the quail as they move into my yard.

I sit perfectly still, bending forward with my eye in the viewfinder and wait for the quail to move into the frame of my shot. Often, they will walk up to about six feet away from me, the males communicating with the females the entire time.

"It's all right," they seem to be saying "He's not moving, and he puts the birdseed out for us every day."

But make no mistake, the slightest movement on my part will send these quail running for the safety of the bushes or even up into the trees. It is a very delicate matter photographing the quail, as it is with the California Thrasher, another wary species. Often I'll be photographing the Scrub Jay on the platform feeder and suddenly the thrasher will hop up onto it for a few minutes. But if he's already on the feeder and you move in his direction, he'll usually jump off, whereas the Scrub Jay and the California Towhee will remain on the feeder, depending on how far away I am. I have been successful

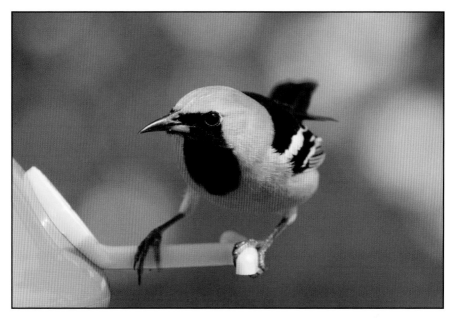

Hooded Oriole

at making one particular California Thrasher get used to me, as he passes through the yard throughout the day and hops onto the feeder whenever he wants. He must have been observing the goings-on in the garden for quite some time to become this comfortable with the surroundings here. The California Quail has become accustomed to flying up to the green platform feeder as well, and I can get quite close to him by now in order to photograph him at that feeder.

In fact, the California Quail is so used to me that he often perches on the empty platform feeder for long periods of time, as if he is trying to tell me to get out there and fill up the feeder with birdseed. If I see him in this position, I'll bring him the birdseed. He hops off the feeder onto the ground as I approach, but a few minutes after I've gone back into the house, he's up on that platform feeder eating the birdseed. Then another quail may join him up there, usually his mate.

What makes one bird species particularly shy and another more trusting of humans is beyond me, but I have learned to adopt varying methods of getting close enough to each type of bird in order to get the best photograph that I can.

In the case of the Hooded Oriole, I actually move his feeder closer and closer to the open window through which I photograph him from inside my TV room. Starting at about sixteen feet away, when he arrives in the middle of March from his wintering grounds in Mexico, I gradually move the feeder closer to the house over the next few weeks, in order to get close shots of the oriole. I use the yellow flowers and green foliage of the bush daisy as a background for these shots.

I was in for a big surprise in the spring of 2013 when I moved the oriole feeder to the canyon side of the pool and discovered that the oriole wouldn't fly off every time I walked across the patio to the main part of the garden. He's not afraid of me, I thought. I wonder how close I can get to him now, while I'm outside. I discovered that he would let me get as close as nine feet away from him as he drank the sugar water from the oriole feeder—right out there in broad daylight. I took full advantage of this, and I felt that I had reached a new level of understanding with this oriole. As it happened, at this time of year, the Mexican marigold plant behind the oriole feeder was in

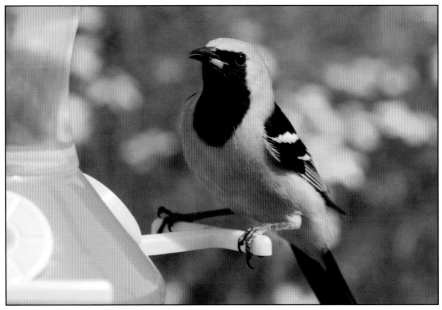

Hooded Oriole and Mexican marigold

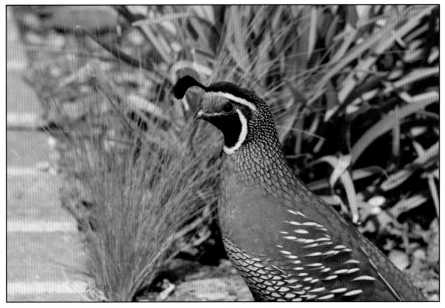

California Quail

full bloom, so I used these golden flowers as a background against the yellow of the bird and the orange of the feeder.

Perhaps the most important aspect of getting close to the birds is having the patience to wait until the right photographic opportunity presents itself. When using the ground feeder with mixed birdseed, I might have to wait an hour or longer for the Spotted Towhee to move into the frame of my camera. He stalks me from afar, wondering if it's safe to move in closer. He glances at me and hops across the brick path as if he is going over there to find something important. He is merely scoping me out from another vantage point. He hops back across the path, from whence he came, then moves through the bushes closer to the birdseed. I wait him out. I tell myself that this bird will not outlast me. I will win in the end. I just have to keep myself bending over, with my eye in the viewfinder, and not moving. Eventually, that brown, black, and white bird with the red eye moves into the frame, for perhaps five or ten seconds, just long enough for me to capture a few images of him before he retreats into the bushes.

Since the Allen's Hummingbird is very territorial, he chases all the other hummingbirds out of my garden in order to have the hummingbird feeder all for himself. This has been going on for years. After chasing a rival out of the yard, the hummingbird often returns to the hummingbird feeder for a victory drink. I have learned to start looking through the viewfinder when these episodes occur, so that I am ready when the hummingbird returns.

I have also learned that hummingbirds visit the hummingbird feeder and the flowers more often in the hour or so before the sun goes down. As their feeding activity intensifies during these times, I am looking through the viewfinder more often in preparation for their arrival. If a hummingbird arrives at the feeder and I move my head down to the camera, I am liable to scare him off, but if I am already in position to take the photograph, the hummingbird will not be flushed away by any movement on my part.

As I discussed earlier, I have photographed the Allen's Hummingbird mother and chicks on the nest a number of times, and this is always a satisfying, if difficult pursuit. Indeed, getting to within

inches of a wild bird and producing a beautiful image is about as rewarding as backyard bird photography gets. In the end, it's all about your relationship with the birds. Are you patient enough to take the time to build up their trust? Do you study their habits in order to anticipate their movements, what time of day they will appear in the yard, and what they'll do once they get there? If you get close to the birds in all of these ways, then you are ready to start composing your bird photographs.

American Goldfinches

⑤
Composition

"Every move must be smooth and almost automatic and all attention must be centered on the birds, their actions, the best composition for capturing the feeling of the moment."
—Allan D. Cruickshank, *Cruickshank's Photographs of Birds of America*

As with all photography, the composition of your bird photographs will determine just how successful your images will be. Composition involves such things as where in the frame your bird appears, how large or small he is, whether he is lit from the front, side, back, or even from above, and whether the background is green, yellow, pink, or purple. All of these decisions contribute to the story you want to tell and to the emotional reaction you hope to elicit from the viewer.

But before we discuss these issues, let's consider how a photograph is produced and how this relates to bird photography. Every photograph is a combination of two primary elements: how much light is allowed through the aperture of your camera, and the speed of your shutter. Depending on which settings you use for these parameters, you can create different effects with your bird photographs.

The aperture is the opening in your camera that gets larger or smaller depending on which f-stop you use. The higher the f-stop, the smaller the opening; and the lower the f-stop, the wider the opening. Therefore, if I shoot at f/8, I will have a smaller aperture than if I shoot at f/5.6. This creates a critical component to bird photography (and indeed, to all photography), which is known as depth of field. Depth

of field simply means how much of your subject will be in focus across a certain plane of view.

For instance, if you want the beak of a bird as well as its feet to be in focus, you need to use a higher f-stop. However, this higher f-stop will cause your background to be more in focus as well, so you should be careful not to use such a high f-stop that your background becomes so busy that it competes with the subject of your picture.

I have discovered, when photographing birds at close range, that setting the aperture at f/8 gets as much of the bird in focus as I need while not making the backgrounds so delineated that they distract the viewer from the bird. At the same time, the backgrounds have enough texture that the viewer gets a sense of the environment in which the bird exists—whether this includes shrubbery or colorful flowers.

I also like to use a shutter speed of at least 1/500 second, in order to stop the movement of the birds, which are almost always in motion when they are feeding and even when they are perched. If you watch a bird carefully, you will learn to anticipate when he will stop his head movements for just a second to check out his surroundings. That's when you want to press the shutter button. It is critical that the bird's eye be in focus, and it is even better if you can capture the "catch-light," or the sun's reflection, in the eye of the bird.

Of course, you can take a great bird photograph at shutter speeds of less than 1/500 second and at f-stops lower than f/8, depending on the light conditions. Since I usually shoot in program mode, I normally adjust the ISO setting so that I am shooting at 1/500 second at f/8, or above. These are not hard and fast rules. If you shoot at a lower f-stop, your background will be more blurred and this may suit your style better. However, you may sacrifice some depth of field on the bird itself, depending on how close the bird is to you. The farther the bird is away from you, the lower the f-stop you can use and still keep the bird in focus. Conversely, the closer the bird is to you, the higher the f-stop you will need in order to get as much of the bird in focus as possible.

For backyard birds in flight, as discussed earlier, I use shutter priority set at 1/1600 second or above, while keeping the f-stop at f/7.1 or f/8, if possible. This usually necessitates using a higher ISO than for

perching or feeding birds, as the faster shutter speed allows less light to reach the sensor and the aperture setting you need to get the bird in focus also means that less light hits the sensor. Therefore, the best time to take photographs of birds in flight is when the sun is shining brightly on your subject.

In the old film days, I used 100, 200, and 400 ASA color slide film. The higher the ASA number, the "faster" the film is, meaning you can shoot with faster shutter speeds, higher f-stops, and in lower light conditions than with the lower ASA film. However, the lower the ASA of your film, the higher the quality (i.e., the sharpness of the image). So there is always a trade-off between quality and speed with film.

In digital photography, the speed of the sensor is measured in ISO settings. The higher the ISO, the faster the speed of the sensor, but the lower the quality, as with film. This means that the higher your ISO is, the less sharp your image will be and the more "grain," or "noise," will show up in your photographs. This grain takes the form of small dots that may appear in your shot, especially in bare patches of your picture, such as a blue sky. Where the image has a higher degree of content, this grain is generally not as noticeable.

Although shooting at a low ISO is desirable, I have discovered that using 400 ISO for most of my backyard bird photographs when using the 100–400mm lens has allowed me to achieve a fast enough shutter speed to stop the action and a high enough f-stop to get as much of the bird in focus as possible. Photographing backyard birds at close range is far different from photographing birds across a wide landscape, where shooting at 100 ISO is effective because you intend to crop and enlarge your photograph so that the bird becomes large in the frame. I use this technique when photographing the Red-tailed Hawk when he flies over the garden, as I quickly set the ISO to 100, the f-stop to 5.6 in aperture mode, and I pan with the bird. However, I have tried using 100 and even 200 ISO with my backyard birds from a distance of six to eight feet, and very often I have out-of-focus subjects because the shutter speed is reduced to, say, 1/320 second or slower, and the f-stop is 5.6 or so. At such close range, even if I manage to stop the motion of the bird, parts of the bird's body, such as the wing or the

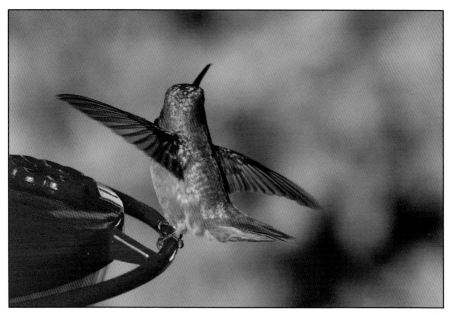

Allen's Hummingbird

feet, may be out of focus because I have reduced my depth of field, so I end up with an unsatisfactory photograph.

I use a higher ISO for capturing birds in flight in the garden, from 800 ISO up to as high as 2500 ISO or higher in bright sunlight, especially when I am using my 180mm macro lens and the 1.4x teleconverter for the hummingbirds. I have discovered that when photographing hovering hummingbirds with the 100–400mm lens, using 1600 ISO and shutter priority set at 1/2000 second produces satisfactory images. Because of technological advancements in digital cameras, the higher ISO settings do not produce nearly as much noise as they did in the past, and if necessary, you can edit your images in a software program. Since every moment in bird photography is precious, I choose to make sure I can stop the action and achieve a good depth of field before I worry about the noise in my images. I only have one chance to get each picture, and I try to make the most of it.

Backyard bird photography presents limitless opportunities for composing your bird photographs. Are the birds that you are going to

photograph large or small? Are you going to include feeders in your images, or are you going to take a picture of a bird while he is perched in a tree, or, in the case of a hummingbird, hovering at a flower? How about your birdbath? Maybe a few nice shots of the birds bathing or drinking will be successful. In each of these cases, you have to consider where in the photograph to position the bird, what kind of lighting you are going to use, and how your backgrounds are going to appear. When all of these ingredients are working together, the result will be a beautiful bird photograph.

As in all photography, it is usually not a good idea to position your subject directly in the center of the frame. Placing the bird a little bit off center creates more interest and drama in the photograph. If you feel a little more adventurous, try placing the bird to the left or right of the frame and let your background play a larger role in the composition. It is also important in bird photography to leave more open space in the direction in which the bird is looking, thus giving the impression that the bird will be moving into this open area at

California Towhee at birdbath

some point. A good example of these principles is a photograph I took of the Allen's Hummingbird at the feeder in my Los Angeles garden. Here, the bird is positioned on the left, with an open area to the right of the bird. Since this bird is just about to fly off the feeder, the open area shows where he will be going in just an instant.

There is a concept in photography called the "rule of thirds," in which the image is broken down into thirds, both horizontally and vertically. This results in nine equal sections of the frame. The four corners of the central box and areas along the horizontal and vertical lines are referred to as "points of interest," which means that the human eye detects these areas more readily than if the subject were merely placed in the center of the photograph. While not an exact science, the rule of thirds is a useful guideline for positioning your bird within your photograph, both through the camera and when you are cropping.

An example of this principle can be seen in my photograph of the California Towhee at the birdbath. Here the bird is placed in the upper

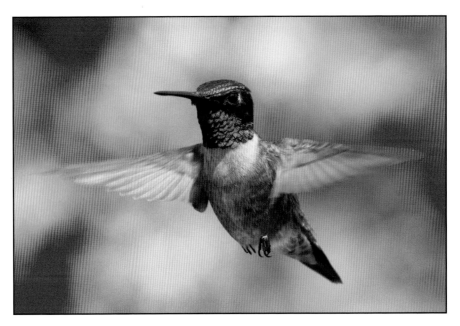

Ruby-throated Hummingbird

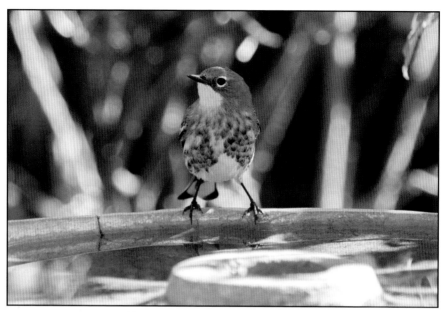

Yellow-rumped Warbler at birdbath

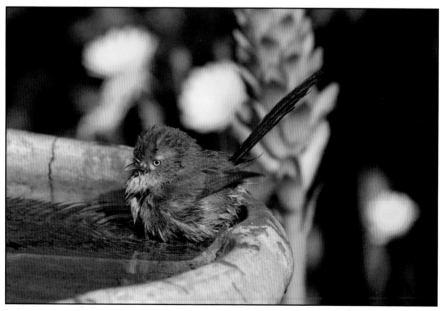

Wrentit at birdbath

left portion of the frame, in the general vicinity of the upper left inter-section of the central box. In addition, the bird's head is placed along the line indicating the upper third of the frame horizontally. This adds a second point of interest. This composition was done in a crop in this instance, as the original photograph consisted of the bird positioned lower and in the middle of the frame, with more of the foliage at left in view.

Framing a bird effectively is especially important when you are using colors in your background. For instance, in Vermont I set up my camera so that the hovering Ruby-throated Hummingbird would appear with the pink rose blossoms on either side of his body. This cre-ates a sense of balance as your eye is brought back into the frame by the blurry patches of pink, only to focus on the bird itself. It is especially rewarding to be able to produce such an image right out of the camera, without any cropping or other manipulation.

In another image of the Ruby-throated Hummingbird, I used the green background of the grass across the driveway to create a uni-form patch of color, and by positioning the bird's body on the right side of the frame, I was able to get his entire wing into the photo-graph as he hovered. A day earlier, I had captured this bird with the same background, showing his iridescent green back, and I managed to get his eye in focus while shooting with a macro lens from four feet away. A certain element of luck is involved with images such as these, but if you are open to your options in composing your photographs, you will have a better chance of creating a more satisfying picture.

Sometimes, positioning the bird's face at the top of the frame is effective, as this allows you to show the rest of his body in your photo-graph. When taking close shots of the Hooded Oriole from seven feet away, I was able to fill the frame just as the bird landed on his perch, but before he had turned his body toward the feeder hole to drink the sugar water. In order to achieve this, I look through the viewfinder as the bird lands on the pole from which the oriole feeder is hanging. I can see the oriole feeder start to jiggle around just as the bird drops down to the feeder hole on the far side of the feeder, over which I have placed a white adhesive label to prevent him from feeding there. In an instant, I know that he will hop over to his regular perch with his

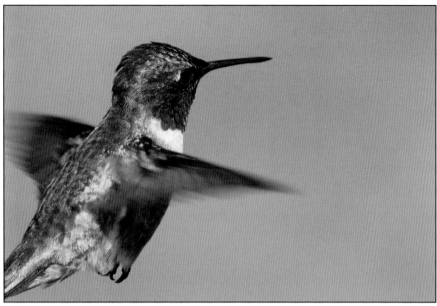

Ruby-throated Hummingbird

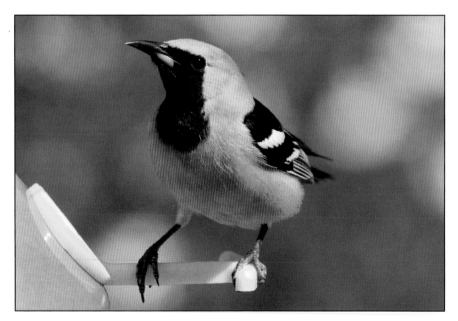

Hooded Oriole

body facing me for a moment, so I start clicking the shutter as soon as he moves into the frame and I can use the autofocus on his eye. Pressing down on the shutter in high-speed continuous shooting mode, I let the AI Servo AF setting of the camera lock in the focus, and if I am fortunate, I can capture a photograph of this shy bird from close range and in a fascinating pose.

In the case of the Hooded Oriole, this particular male and his mate are more than likely the same individuals who have been visiting my garden for a number of years, and over time, they have become accustomed to the noise of the camera from inside my TV-room blind, and even to some of my movements. They certainly see me hanging the oriole feeder on the pole after I fill the feeder up with sugar water. They must, then, associate me with the source of the sugar water in this feeder, and as they visit the feeder year after year and suffer no ill effects from my presence, it must sink in that they are safe around me.

Still, I was amazed in 2013 to discover that by April 11, about three weeks after I started photographing the Hooded Oriole at the feeder, the male became so familiar with me that at a range of only seven feet, he would actually let me talk to him and even move around a little bit from inside the blind, and he would not fly off. (I did this after the feeder had gone into the shade, so I did not miss an opportunity to photograph him in the sunlight, as every visit of the oriole is critical. I never know what I might get, so I don't want to waste a single opportunity.)

I always use natural backgrounds for my bird photographs, so I spend a great deal of time positioning the camera so that the plants in the background present a composition that is not too bright and not too dark. The green leaves of the oleander and bush daisy work very well, and if I want a colorful background, I use the yellow flowers of the bush daisy and the African daisy, or the red flowers of the fuchsia. In Vermont, as I mentioned earlier, the pink flowers of the rose bush provide exceptional color.

In order to achieve the proper amount of brightness in my backgrounds, I must wait until the sun hits the foliage in such a way that there are few shady or dark areas. In my Los Angeles garden, prime time for bird photography is generally from mid to late afternoon or

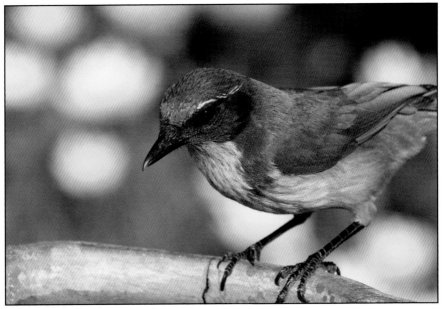

Scrub Jay on birdbath before taking peanut

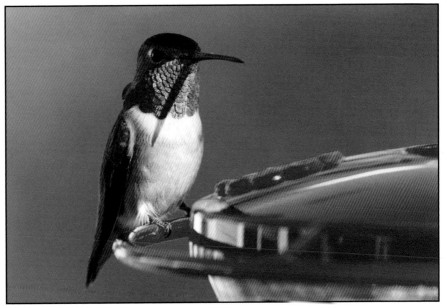

Allen's Hummingbird

early evening, depending on the time of year, so I have enough time to plan out which areas of the garden I will use for my background on any given day.

I get a kick out of placing the Hooded Oriole in front of the yellow bush daisy flowers and the green foliage of this plant. When I combine these colors with the yellow and black plumage of the bird and the orange and yellow colors of the oriole feeder, the result is like a still life, only the subject is living and moving. With the Scrub Jay, I sometimes position his blue and white body in front of some green foliage, and sometimes I use the yellow flowers to combine with his blue feathers in a more flashy composition. In one instance, I put a few unshelled peanuts into the middle of the birdbath, a dry area where the decorative concrete bird would normally be. The Scrub Jays flew down to the birdbath and took away the peanuts, but just before one of the jays jumped over to get his peanut, I caught him perched on the side of the birdbath with the African daisy flowers in the background. It makes an excellent composition, but it was not an accident. The jay is in that position because I had put the peanuts in just the right spot

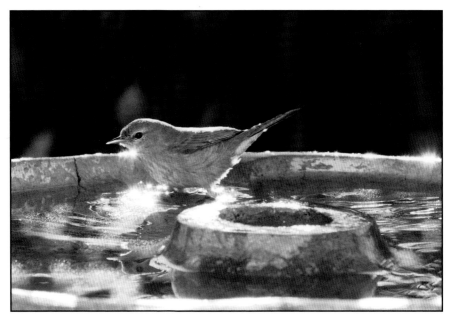

Orange-crowned Warbler at birdbath

so that in order to get them, he would no doubt perch in this area of the feeder after dropping down from his usual position in the orchid tree right above it.

In a way, this is like painting with living ingredients, be they animal or plant. In your own garden, you can experiment with the backgrounds that your plants give you, and then combine these colors with the plumage of the birds that visit your yard to create some exciting photographs of your own.

Two examples of this type of composition occurred when I was producing the hummingbird head shots in 2009. I realized that the Allen's Hummingbird had a combination of brown and green colors in his plumage, and I also noticed that the fuchsia contained red flowers and green leaves. So one day, I tried to position the bird in front of the fuchsia flowers and, presto, I had a study in red, green, and brown. On another occasion, I decided to split the background into two areas of color, pink from the flowers in the top left, and green from the foliage in the bottom right. Into this setting, I placed the Allen's Hummingbird with his green feathers,

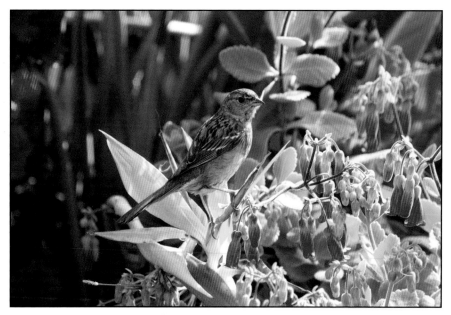

Golden-crowned Sparrow

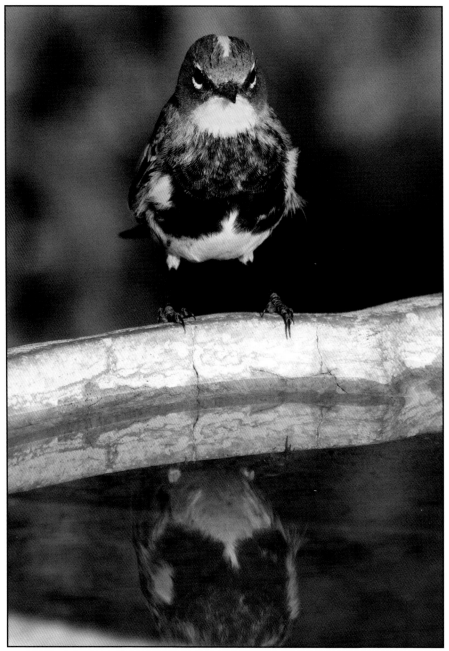

Yellow-rumped Warbler, vertical crop

orange-red gorget, and white-and-brown chest. Photographs like these are not accidents. They require careful planning of both the backgrounds and the position of the birds when they move into the frame of the viewfinder.

While most of my bird photographs are taken with the sun shining directly on my subject, there are times when side-lighting, backlighting, and even top lighting can result in a successful bird photograph. For instance, one day in early January, at about noon, I spotted the Allen's Hummingbird on the feeder and I quickly turned and photographed him with a brilliant ray of sunlight shining on his orange-red throat feathers from the right side of the frame. Although his eye is in the shadow, the contrast between the colorful throat feathers and that eye looking out at you from the shade makes this photograph resonate

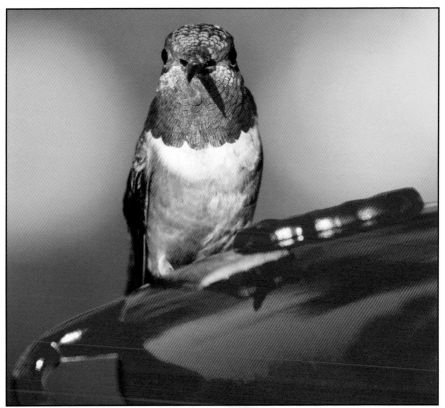

Allen's Hummingbird

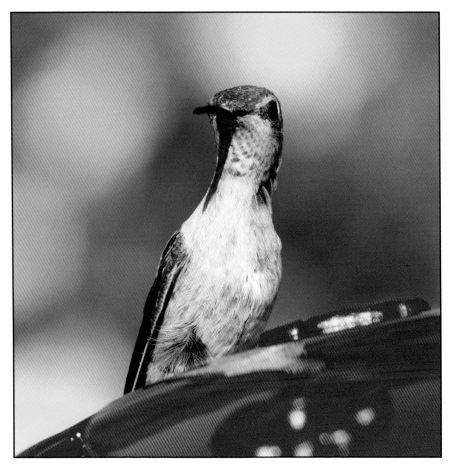

Black-chinned Hummingbird

with spontaneity, as if this were the only time that this photograph could have been taken, a frozen moment between me and the bird.

Although I usually take photographs of the birds at the birdbath in the afternoon, I decided one morning to photograph with the sun shining into the frame from behind the birdbath, hoping to catch some reflections in the water and some interesting rays of light. Fortunately, an Orange-crowned Warbler posed for me that morning in just the right spot, making a brilliant reflection burst forth from just under his

chin. The sunlight of a new morning reveals itself in this image, as the bird embarks on his journey throughout the day.

On another occasion, mid-afternoon on a winter day, I turned myself toward the setting sun and caught an image of the Allen's Hummingbird as he drank in the sugar water at the hummingbird feeder. In this instance, the backlighting created a sort of halo behind the bird and it also formed a bright reflection off of the bird's foot. I couldn't have planned for this. It just had to happen.

Backlighting can also be achieved by shooting in the early evening, as I did one day in May with the Hooded Oriole. In this image, the feeder itself acted as a reflector and cast a yellow light onto the front of the bird, as the sun's golden rays illuminated the back side of the bird. A few days earlier, again in the early evening, a Scrub Jay had landed on the pole from which this oriole feeder was hanging, and I

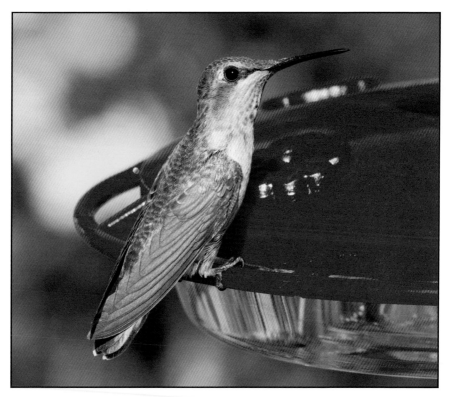

Black-chinned Hummingbird

managed to get a backlit shot of this bird. The uniform background in this image was created by the blurred trees on the other side of the canyon.

A good example of top lighting exists in a photograph I took of a Golden-crowned Sparrow perched on a bird of paradise flower. Taken at midday, the tubular flowers were given a special resonance, and fortunately, the pink flowers at the left of the frame balance out the red flowers at the right. The bird, being lit on the top of the head, looks magnificent.

The lesson here is that sometimes it pays to photograph birds at different times of the day in order to produce a desired effect. While standard lighting works in a majority of cases, keep your eyes open for the moments when unusual lighting can add an extra element to your photographs.

While most of my bird photographs are produced in a horizontal frame, there are times when framing a subject vertically brings out something special in an image. For instance, one day I took a photograph of the Yellow-rumped Warbler at the birdbath, with a partial

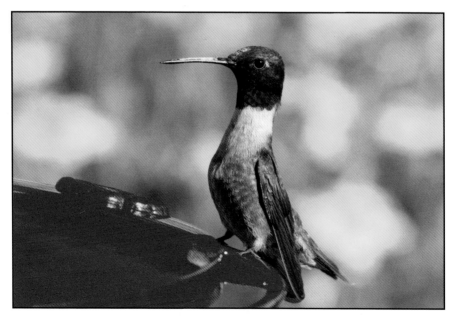

Black-chinned Hummingbird male and Mexican marigold

reflection of his body in the water. I was careful to frame the bird just to the left of center in the horizontal image, but I realized that I couldn't make the bird larger without losing part, if not all, of the reflection of the bird in the water. By cropping this image vertically and still leaving the bird a tiny bit left of center, the bird itself and his reflection is highlighted more.

In May of 2013, I discovered another interesting aspect of composition when I decided to use a square crop on my hummingbird photographs. Placing the bird in the upper left of the frame creates a sense of drama that I might not otherwise have in these photographs, as the hummingbird looks down at me from his perch on the feeder. I tried this technique with the Allen's Hummingbird and with the Black-chinned Hummingbird, with the bush daisy as a background, and was very pleased with the results. I think it would be interesting to do an exhibition of hummingbird images using this square crop format. Each print would be a little jewel, like the hummingbirds themselves. A diptych or triptych of hummingbird photographs using the square crop would be interesting as well.

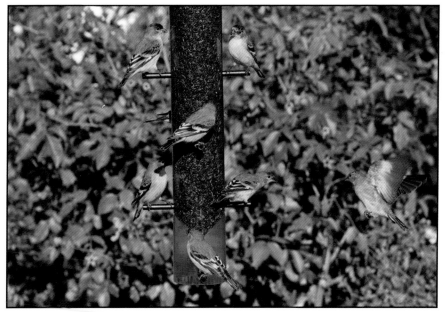

Lesser Goldfinches at feeder

Nanday Parakeets and moon

The following month, I continued photographing the Allen's and Black-chinned Hummingbirds at a feeder that I had placed in front of a Mexican marigold plant on the canyon side of the pool. Here, I spent some wonderful afternoons producing images of these birds with the golden flowers of the Mexican marigold in the background.

In one magical moment, I captured the male Black-chinned Hummingbird as he perched on the feeder about eight feet away from me. That beautiful purple on his neck, combined with the yellow flowers and that lively look on his face make this one of my favorite bird portraits. Although the female Black-chinned Hummingbird continued to visit the feeder, the male flew through the yard almost every day but I never saw him perch on the feeder again.

While I normally concentrate on getting a good close-up of an individual bird, there are times when photographing groups of birds can be an effective means of composing your bird photographs. One day, while photographing the Lesser Goldfinch at the Nyjer feeder in Los Angeles, I decided to try to get a photograph in which each of the feeding perches was occupied by a goldfinch. Looking through

the viewfinder, I watched the goldfinches fill up the perches one by one until they were all occupied, and then I clicked the shutter. As I did so, an extra goldfinch flew into the frame at the right, and I was lucky enough to capture him in mid-flight, being stared down by the goldfinch on the perch closest to him. I don't remember whether he got this perch away from his rival, but the picture tells a nice story.

While I am out in my garden in the late afternoon, the local flock of Nanday Parakeets often flies over my house. I usually hear them squawking down the street in advance, where a neighbor has put up a tube feeder filled with black oil sunflower seeds for these birds. When the squawking finally reaches a frenzy, they are usually ready to take off, and they always fly in a northwesterly direction up the street on which I live. It just so happens that at this time of day the moon is rising in the east, so I decided to try to catch the parakeets in flight with the moon in the background. As soon as I figured they were ready to take off, I readied my camera, handholding it this time to have a better chance of catching them in the frame, and when they flew by,

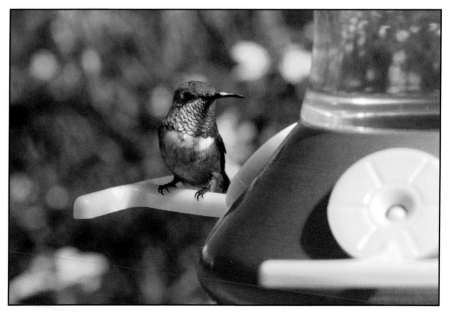

Allen's Hummingbird perched on oriole feeder

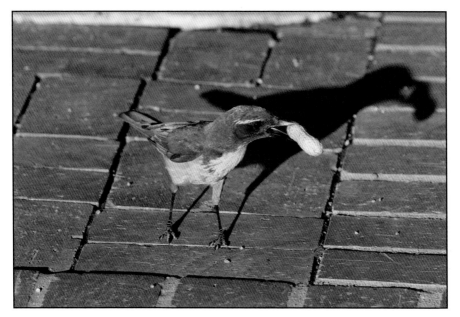

Scrub Jay with shadow of bird and peanut

I panned along with the birds and pressed the shutter on high-speed continuous shooting mode.

As discussed earlier, when a group of Nanday Parakeets lands on my platform feeder, this provides an opportunity to photograph a collection of individual birds of the same species. This also occurs when a flock of Bushtits stops at the birdbath for a communal drink. In Vermont, groups of American Goldfinches often perch on the Nyjer feeder, giving me a chance to capture a number of birds in the same shot.

As for using flowers in your garden as backgrounds for your bird photographs, keep in mind that flowers of different plants bloom at different times of the year and for specific periods. The yellow flowers of the bush daisy in my Los Angeles garden will bloom at any time during the year, but there are times when the yellow flowers disappear and the plant only consists of green leaves. So if I want those yellow flowers in the background of my photographs, I have to be sure to take those images while the flowers are in bloom. Similarly, in Vermont the bee balm flowers are at their peak in early July, and

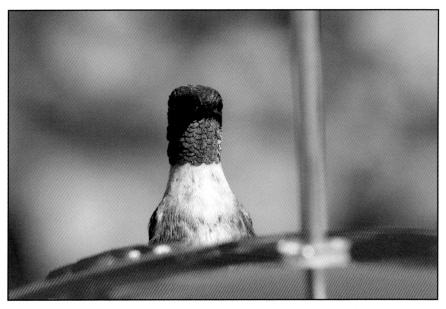

Ruby-throated Hummingbird looking across feeder

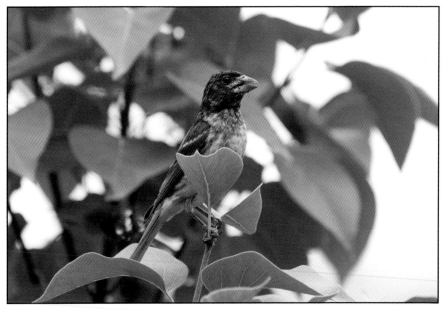

Purple Finch in tree

by the end of the month they have gone to seed. Therefore, when you have a flower that makes a good background, take advantage of it while it's in bloom.

Another principle of composition is to be prepared for the unexpected. For example, although I put out the oriole feeder for the Hooded Oriole, the Allen's Hummingbird and Black-chinned Hummingbird also use this feeder for the sugar water that it contains. Usually, the hummingbirds hover while poking their bills into the feeder holes, but the Allen's Hummingbird has learned to stand on the perch while feeding, thus giving himself a little rest.

While I may be photographing the Hooded Oriole at his feeder on any given day, I also have the opportunity to photograph the hovering hummingbirds at the oriole feeder, too. As with any flying shots, this requires changing the settings on the camera to a higher shutter speed and ISO, then changing the settings back to a lower shutter speed and ISO for the oriole.

Another unexpected compositional treat occurred late one winter afternoon in Los Angeles when I was taking close shots of the Scrub

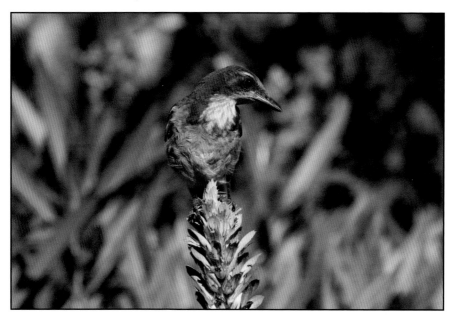

Juvenile Scrub Jay on bear's breeches stalk

Jay at the ground platform feeder on my patio. Suddenly, I realized that the sun was casting the shadow of the Scrub Jay on the patio behind the bird itself. I then challenged myself to get an image in which not only the shadow of the bird was in the photograph, but the shadow of the peanut in his beak as well. I had to stand up to get this shot, looking down on the bird, but I succeeded in achieving my goal.

And talk about unexpected, while I was photographing the Hooded Oriole on the canyon side of my yard one day, I heard a splashing noise. Looking back across the pool toward the main garden, I saw a Scrub Jay jump onto the first step of the pool, drop down onto his stomach to cool off in the water, and then fly up out of the pool, all in one motion. I instinctively turned the camera in the direction of the Scrub Jay, and he just stood there on the patio. "Come on," I thought. "Go in again, just for me." And that is exactly what he did. A repeat performance, and this time I was ready with the camera and caught the action.

Over the years, there seems to have been a taboo among "professional" bird photographers against having birdfeeders and other

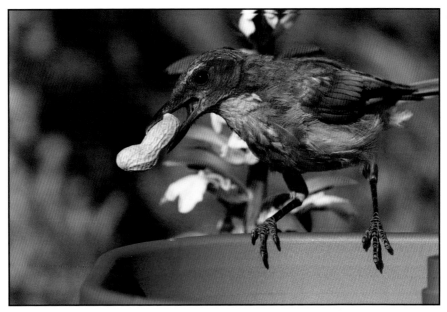

**Scrub Jay on platform feeder, with bear's breeches
stalk in background**

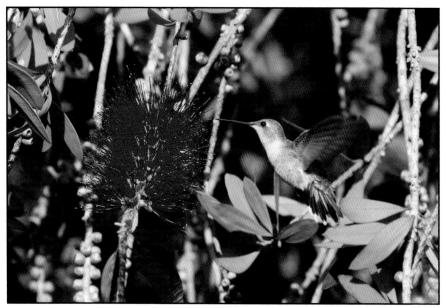

Black-chinned Hummingbird at bottlebrush

manmade objects in bird photographs, even if the image is produced in one's own backyard. This seems rather shortsighted to me, as it is only natural for the birds to use the feeders in our gardens. So why not use the feeders as compositional elements in our photographs? After all, human beings are photographed with all sorts of artificial objects around, such as tables, chairs, automobiles, etc. Why does every bird photograph have to consist of a bird sitting on a branch?

Having decided to include the feeder in the photograph, however, I consider it essential that the feeder be spotless in order to keep a clean look to the image. This requires constant diligence during my shoots, as I wipe off the green platform feeder every time the Scrub Jay lands on it, and I wipe off the hummingbird feeder every ten minutes or so, even removing tiny bits of dust with my finger. So it is no accident that when a birdfeeder appears in one of my bird photographs, it does not have a speck of dirt on it. When the feeder is kept clean, it becomes an important element in your photograph, adding to the beauty of the subject matter. This will elevate your backyard bird photographs from being mere snapshots to becoming works of art.

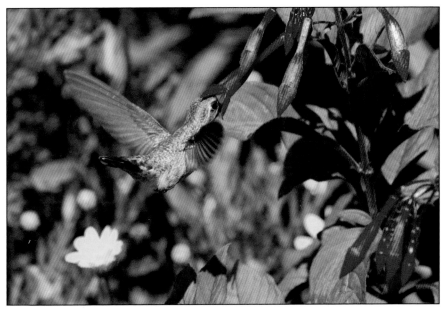

Black-chinned Hummingbird at fuchsia

Indeed, the hummingbird feeder becomes an important aspect of the composition of a photograph I took of the male Ruby-throated Hummingbird in my Vermont garden. In this image, the male is checking me out by looking across the feeder. At first, I thought the feeder's golden hook on the right side of the frame ruined the shot, but then I decided that in this case the inclusion of the hook tells the story of this hanging feeder and the little bird that is perched on it.

Similarly, with my series of hummingbird photographs in which I use a square crop, the red plastic of the feeder is an integral aspect of the composition. I equate it to producing a portrait of the President of the United States in the Oval Office and all of the elements of that environment that contribute to that image. In this case, the hummingbird feeder is the hummingbird's Oval Office and he's the boss.

Of course, catching your backyard birds in natural poses in your foliage presents countless opportunities for your bird photography. It was just after midday in Vermont when the male Purple Finch grasped hold of a stem and gazed down at me as he waited to fly over

to the platform feeder for some birdseed. Since the sky was overcast, the white and green background fell into place as the reddish bird stood in the middle of the frame.

In another instance, I decided to photograph the Scrub Jay in a tree with a focal length of 220mm, instead of the usual 400mm. The bird is smaller in the frame than my usual images, but this shot allows you to get a sense of just how small this bird is in the scheme of things as he perches on the branch with his peanut. The blurry trees in the background complete the composition of this photograph, and a sense of drama is achieved.

On another occasion, I noticed that the bear's breeches stalk had grown up higher than the platform feeder on a pole, and at first, this bothered me because I wanted a clean background for the photographs of the Scrub Jays on the platform feeder. However, the birds decided that the top of this stalk was a good perching spot from which to drop down onto the platform feeder. One day in July, a juvenile Scrub Jay landed on top of this stalk, and I was quick enough to grab a shot of him before he jumped over to the platform feeder. This same stalk provided a valu-

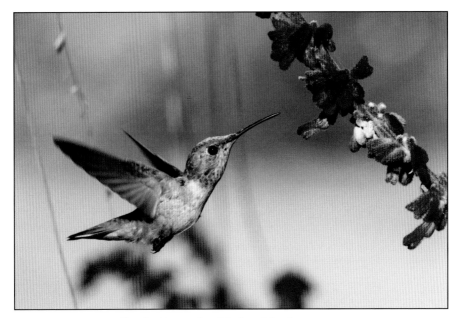

Allen's Hummingbird at Mexican sage

able compositional element for a photograph I took of another Scrub Jay perched on the platform feeder, with a peanut in his beak. Without the stalk in the background, this image would be far less intriguing.

One day in April, I captured an image of the female Black-chinned Hummingbird as she approached the flower head of a bottlebrush plant while hovering alongside it. I had been photographing the Allen's Hummingbird at the hummingbird feeder just a few feet away, and I suddenly realized that there were a number of hummingbirds flying around the bottlebrush flowers. I quickly moved the tripod and camera over to this area of the garden and managed to take a naturalistic photograph right in my own backyard. On another occasion, I took a photograph of the Black-chinned Hummingbird with her beak and part of her head poked into a fuchsia flower.

And later that spring, I had a wonderful run of photographing the Allen's Hummingbird hovering alongside the Mexican sage on the canyon side of the pool. It was a challenge to keep up with the fast-moving bird as it poked its beak into each flower, but I concentrated and pressed the shutter at just the right moment on a number of occasions. Late one afternoon, I decided to photograph the hummingbird into the sun, which resulted in an evocative image of a backlit Allen's Hummingbird feeding at the Mexican sage.

I hope these examples show you that you can use your imagination and be creative with the composition of the bird photographs that you take in your garden. All of these aspects of composition are personal, and you should choose the styles that suit you best. In general, your backyard should present you with a good variety of settings in which to take your bird photographs, and you should feel free to take advantage of each of these opportunities.

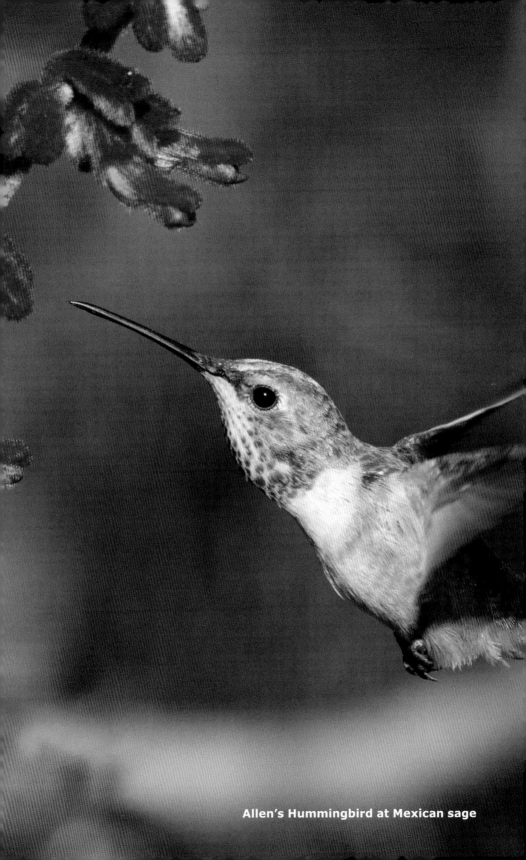

Allen's Hummingbird at Mexican sage

Allen's Hummingbird

⑥

Other Backyard Bird Photography Techniques

"There is something rather different about tackling bird photography at home. . . . The birds are more intimate. They are accustomed to the presence and the activities of man, and may be expected to be more tolerant of our approaches to them."
—Eric Hosking, *Bird Photography as a Hobby*

While most of my backyard bird photographs are taken of perched birds in well-lit conditions, there are some special strategies I have employed to increase my chances of getting a great bird photograph under other circumstances.

No matter which lens I am using, photographing birds in flight requires very fast shutter speeds in order to stop the action. If a bird is flying across my plane of view at a great distance, I pan the camera at the same speed as the bird and press the shutter down on high-speed continuous mode, with the focus set at AI-Servo and the Spot AF point right on the bird. The farther away the bird is from me, the better chance I will have of getting the moving bird in focus, as my depth of field is greater than if I were right next to the bird. In other words, the camera has to focus on a smaller portion of the frame and the depth of the subject can be captured completely by the camera, rather than just a portion of the subject, and at a lower shutter speed and ISO setting.

For most of us with modest-sized yards, a bird in flight will move out of the garden within a second or two, so it is important to use a fast shutter speed (at least 1/1600 second) and a high enough f-stop (at least f/7.1 or f/8) in order to get the bird in focus. In these

cases, I focus on the bird itself or on an area around the edge of the birdfeeder and click the shutter on high-speed continuous mode just as the bird takes off, or perhaps a moment before. I can sense when a bird is about to fly from the feeder by anticipating when it has had its fill of food, and also by watching its body movements. For instance, if it turns its head from side to side after a good feeding session, it's often ready to fly off. By observing the feeding habits of different species of birds, you will learn just how long they spend before they leave the feeder. The Mourning Dove and House Finch may stay on the feeder for five to ten minutes or longer, but the Spotted Towhee often takes only a few minutes to get his fill. Also, most birds bend their legs to push off of their perch just before they actually take to the air. Watch for these signs and press the shutter button when the time is right.

When the bird takes off, he will be moving too fast to pan and keep up with him, so it is best to try to anticipate which direction the bird will fly, based on his previous departures, and then frame your image with open space in front of the bird in the direction in which

Hooded Oriole flying off from feeder

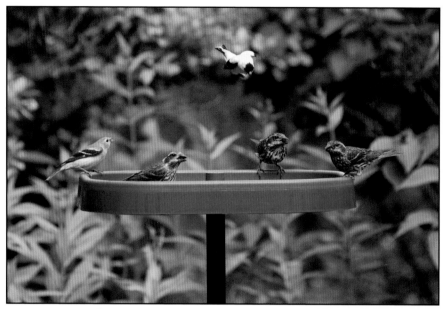

**American Goldfinch flying to feeder, with another
American Goldfinch and three Purple Finches**

you think he will fly. If the bird does not move out of that area too quickly, you may just catch him in flight, and in focus.

When using manual focus with my 180mm macro lens for a Ruby-throated Hummingbird that is hovering above a feeder at only four feet away, I find it best to first focus on the feeding hole where the bird is drinking, then tilt the camera up into the space where I expect the hummingbird to go when he hovers between sips, then let the hummingbird appear in the frame, and then press the shutter after I fine-tune the focus on the bird as it's hovering. The Ruby-throated Hummingbird, while hovering, will take a few sips of sugar water and then rise up over the feeding hole for a few seconds, then drop back down for a few more sips, and he'll repeat this activity numerous times during a feeding session. I learn to time these episodes and I am ready for him to fly into the frame just as I focus and click at virtually the same time. It's tricky, but it can be done. I used this same technique for photographing the Ruby-throated Hummingbird in Vermont with the 100–400mm lens at distances of from six to fifteen feet during the summer of 2012.

When photographing hovering hummingbirds with my 100–400mm lens in Los Angeles during the spring and summer of 2013, I used the AI Servo AF mode set at Spot AF, which meant that I could press down on the shutter lightly and the camera would continually focus on the spot where the AF point was located on the body of the hummingbird, preferably on the eye. Then I pressed the shutter button in high-speed continuous mode to get a series of shots all at once, hoping that one of these images would be in focus and give me the right exposure and composition.

I have photographed various birds in flight in my Los Angeles garden, such as the Scrub Jays carrying peanuts from both the ground platform feeder and the green platform feeder on a pole; the Hooded Oriole flying off of the feeder; the Allen's, Anna's, and Black-chinned Hummingbirds hovering while feeding on a flower; and the Red-tailed Hawk and Nanday Parakeets flying over my yard. In Vermont, I captured the Ruby-throated Hummingbird hovering over the feeder, and by chance I caught an American Goldfinch as he dive-bombed down to the green platform feeder to find his place among three Purple

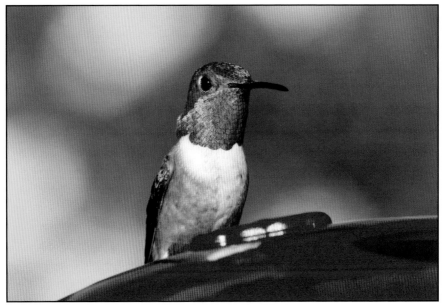

Allen's Hummingbird

Finches and another goldfinch, who was calling out to him with some irritation over his presence. You can't really plan for moments such as this, but when you happen upon them, consider it a backyard bird photography gift.

For a while, I switched back and forth between program mode for the perched Allen's Hummingbird and shutter priority at 1/2000 second for the hovering hummingbirds. If the Allen's Hummingbird flew in and perched when I'd been expecting a hovering hummingbird, I turned the dial on top of the camera from shutter priority to program mode with my left hand, which flushed the bird off of the feeder. One day, I realized that if I kept the camera in shutter priority the whole time, I could change from 1/2000 second to 1/500 second and lower the ISO from 1600 to 400 with my right hand (which was already in place to press the shutter), and the hummingbird would not see any movement. When I tried this, I ended up with a shot at 1/500 second and f/10 in shutter priority instead of 1/640 second at f/8 or 1/500 second at f/8 in program mode. This higher f-stop gave me a larger depth of field and helped me get more of the hummingbird's head in focus. Thus, sometimes experimenting with your shooting modes can produce positive results.

As stated earlier, photographing hummingbirds with a 180mm macro lens presents its own set of challenges, but the results are worthwhile. For a number of years when I was using my Digital Rebel, I had been wondering how to get close enough to the hummingbirds to fill the frame with their heads. The Tamron 200–400mm lens would only focus as close as eight feet away, and even with a 1.4x teleconverter from that distance, I was unable to get closer than the hummingbird's body filling up the frame.

Then I decided to purchase a 180mm macro lens, attach the 1.4x teleconverter to it, and try to get as close to the hummingbird as I could without the hummingbird flying off or choosing not to visit the hummingbird feeder in the first place. On a warm spring day, I put the camera on the tripod and stood a few feet away from the feeder and waited for the hummingbirds to fly in for the sugar water. Over the next few weeks, I produced a number of hummingbird portraits as I discovered that if I stood perfectly still, the Allen's and Anna's

Hummingbirds would actually perch on the feeder and continue to drink the sugar water as I photographed them from less than three feet away. I waited until they lifted their heads up from feeder and looked around, especially at me, and then clicked the shutter, setting the camera on manual exposure for 1/1000 second and f/8, and the ISO at 1600.

I had to stand at just the right angle to capture the orange-red color of the Allen's Hummingbird's gorget, or the purplish-red of the Anna's Hummingbird's crown and gorget, as these colors are refracted off the birds' feathers, depending on the angle at which the sun hits them, as opposed to being pigments. I anticipated where the sun would hit these feathers when the bird turned his head toward me, and then tried to keep my concentration and get the shot as I became mesmerized by the flash of color that I witnessed through my viewfinder. In one shot of the Anna's Hummingbird, I managed to capture the brilliance of these feathers at just the right moment, and in another, I got the head and body of the Anna's Hummingbird in the frame as the bird was hovering and drinking.

Using an external flash attachment while photographing the Allen's Hummingbird nest in Sherman Oaks presented its own set of challenges. Most of the time, the camera worked well in program mode, but sometimes, after I determined a good exposure setting, I put the camera in manual mode and continued to shoot at this setting. The key with flash is to make the image look as natural as possible, so be prepared to experiment with different settings and then use the settings that work best. As the sun moves through the sky, it will create brighter or darker conditions, even in a shaded area, so you have to adjust for these changes when they occur. For instance, sometimes reflections will brighten up a shady area. At the Allen's Hummingbird nest in Sherman Oaks, the sunlight hit the pool at a certain time in the morning and this caused light to reflect onto the hummingbird nest. Therefore, I had to be careful not to have the flash on too brightly during these periods.

During this shoot, I had to improvise when the single chick in the first brood took his first flight on April 10. First, the fledgling flew over and landed on the handlebars of a bicycle that was standing on the

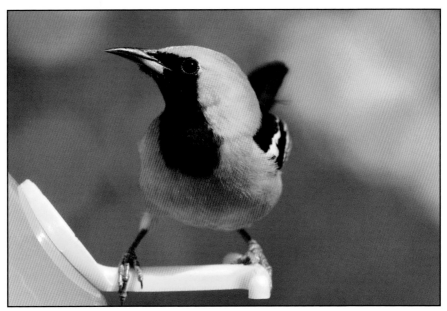

Hooded Oriole

patio. The hummingbird's mother became very distressed and flew over to her little chick, hovering over the baby and squeaking at it, as if to say, "This is no place for you." I swiveled the camera on its tripod, with the flash engaged, and got an image of this interaction using the same 180mm macro lens and 1.4x teleconverter that I used to photograph the birds on the nest. (There was no time to switch to a longer lens.) In this case, the flash served to fill in the light in a shady area where the mother and her fledgling would have appeared very dark without the extra light.

A couple of hours later, the fledgling flew up into a tree alongside the patio and since the bird was directly above me, I could not tilt my tripod back far enough to point my camera up at the bird. In addition, I couldn't move back because the pool was directly behind me. Therefore, I took the camera off the tripod, placed the body of the camera on my forehead to stabilize it, and pointed the 180mm macro lens with the 1.4x teleconverter and the flash attachment up at the tiny bird. It wasn't the most ideal circumstance, but I got a record of that fledgling on its first foray out into the world.

For a number of years I photographed the Hooded Orioles through a picture window in my TV room. For some reason, it never dawned on me that I could take a screen out of the sliding glass window area and photograph directly to the outside, using the TV room as a blind. When I finally did this a few years ago, the quality of my oriole photographs increased dramatically. The Hooded Oriole by now has become accustomed to this opening in the window, and to the noises of the camera from inside the house, but it took many years for him to realize that he was in no danger being so close to me. Still, the female rarely visits the feeder when it is less than ten feet from the open window.

The setup of the blind is very simple. I place my tripod in the corner of the room, and I cover the open area of the front window with an unfolded cardboard box from the floor up to just below the camera, then pull the window shade down from the top, leaving me a small area in which to photograph. I also place an unopened cardboard box along the window on my right side so that the tripod's black rubber feet do not leave marks on the white floor molding. The window shade on this window prevents the birds from seeing me as they fly from their palm tree on the canyon side of the yard over to the patio in the main part of the yard, where the oriole feeder is located. In order to make sure that the wind does not blow back the cardboard, I place a few plastic bins (containing some birdfeeding items to give them weight) on top of each other, so that the top bin can be pushed against the top section of the cardboard to keep it in place. The tripod legs secure the cardboard on the bottom, but when the wind blows up at about 3:00 p.m. every day, the cardboard at the top may be blown back from time to time and I have to straighten it up again by pushing in the plastic bins and the tripod legs. Just behind the tripod, I have a barstool that I can sit on to rest, but I only perch on this seat for a few minutes at a time, because at any moment, the oriole can fly directly to either the feeder pole above the feeder or even onto the feeder itself. By this time, it is too late for me to stand up and place my hands on the camera. The oriole will see this movement and fly off.

I have spent many wonderful hours standing in this corner photographing the Hooded Orioles. I love listening to them chucking and chucking as they approach the garden, then the chucking sound gets really loud when they land on the feeder pole and get ready to drop down onto the feeder itself. Sometimes, especially in August and early September, it gets extremely hot in this corner, and one year it was so hot that I lost my concentration and I thought I was placing the Digital Rebel camera with the 200–400mm lens and the 1.4x teleconverter onto the tripod head, but instead I latched the camera into thin air, then let go, and the camera fell first onto the window stool, a little over a foot above the floor (leaving a one-inch dent), and then onto the tile floor itself. I was in shock, but the camera was not damaged, and I attached it properly to the tripod and kept shooting.

In the case of my hummingbird and oriole photographs, you may wonder how I know that the bird will land on a certain perch of the feeder every time. After all, panning across the feeder with my camera would likely scare off my subject at such close quarters, and besides it wouldn't result in the composition I desire.

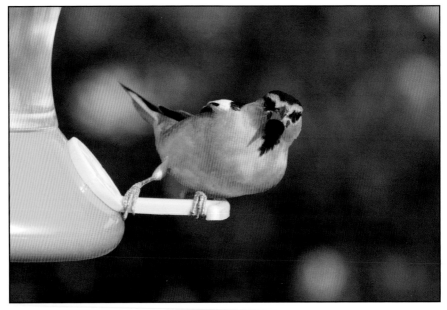

Bullock's Oriole

Here's a little trick. I place a white adhesive label on the outside of the feeding holes where I don't want the bird to go. Or with the hummingbird feeder, I may place blue painter's tape under the feeder holes. Sometimes I leave more than one feeder hole open, just in case an interesting composition arises and I am willing to take the chance of panning to my subject. With the hummingbird feeder, this may result in a shot taken with the hummingbird perched on the opposite side of the feeder and looking directly at me, instead of a profile; and with the oriole feeder, this might produce a photograph in which the oriole is positioned across the feeder in the foreground, instead of off to the side. Similarly, leaving the feeder hole closest to me open on the hummingbird feeder may result in the hummingbird perching with his back to me.

In the case of the Ruby-throated Hummingbird with the rose bush as a background, it was essential to cover the two feeder holes of the hummingbird feeder to the left of where I was shooting. I knew that the hummingbird would go to the feeder hole that was open on the right side of the feeder, and I was able to photograph this bird without

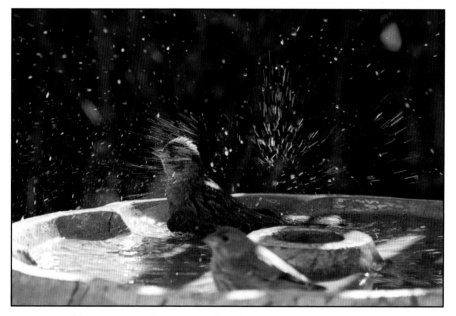

Golden-crowned Sparrow (background) and House Finch (foreground) at birdbath

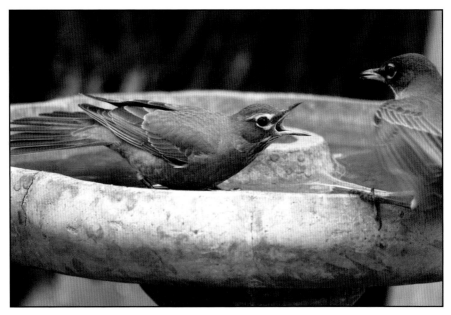

American Robins at birdbath

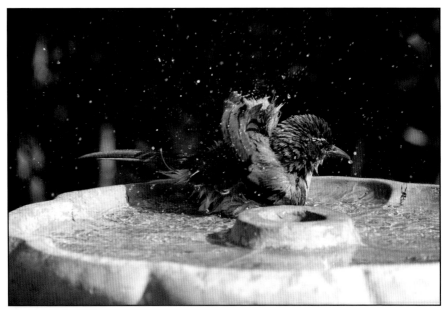

Scrub Jay at birdbath

worrying about which feeder hole he was going to use. If for some rea-
son he chose to use the open feeder hole directly in front of me, I was
happy to shoot him from behind, but this rarely, if ever, happened.

When photographing the Allen's Hummingbird on one occasion,
I left the feeder hole open on the far side of the feeder in order to get
the hummingbird's head facing me with the orange-red color of his
gorget at just the right angle to the sun so that the sunlight refracted
off of the feathers to show the color. In this instance, I had stickers on
two of the feeder holes to the right of the bird but on the feeder hole
just in front of the bird, I used some blue painter's tape on the inside
of the feeder to close off the hole. This resulted in that feeder hole
looking natural, just in case it ended up in the foreground of the pho-
tograph. This is exactly what happened, and I got a charming image
of the hummingbird with his wing outstretched and his reflection in
the feeder, but no white sticker on the feeder hole in the foreground.
Generally, I use the painter's tape on the hummingbird feeder holes
closest to me, and then a sticker on one of the holes on the far side of
the feeder where I don't want the hummingbird to go. This gives me
the flexibility of opening up one of the far holes or the other, depend-
ing on which background I want to use. Sometimes, I use the painter's
tape on all of the holes except the one where I want the hummingbird
to go, and this saves me the worry of having a white sticker show up
in any of the shots.

When taking close shots of the Hooded Oriole on the oriole feeder,
I usually place a sticker on the feeder hole on the far side of the feeder,
and on the hole to the left of where I want the oriole to perch. This
way, every time the oriole goes to the feeder, he perches on the feeder
hole to the right, where I can get a good profile of him with the foli-
age and flowers of the bush daisy in the background. However, one
day in March, the Bullock's Oriole visited the oriole feeder three times
during an hour in the late afternoon. First, he perched at the feeder
hole on the far side of the feeder, which had a sticker on it. I snapped
a shot of him there. Twenty minutes later, he returned and landed on
the feeder hole directly facing me, where I didn't have a sticker. I took
a photograph of him in that position, with his body across the front of
the feeder. A half hour after that, he landed at the feeder hole on the

Band-tailed Pigeon

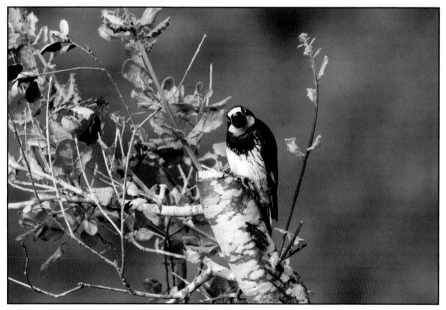

Acorn Woodpecker

right side of the feeder, where I had wanted him to go all along. Here, I got a nice shot of him leaning out from the perch to look at me before he turned back to the feeder hole and took a few sips of the sugar water. Then he flew off, never to return.

Note: I only use the adhesive labels and painter's tape on the feeders while I am photographing. The hummingbirds and orioles soon learn which feeder holes are open on these feeders, and they go to those openings quickly. But when I put my spare feeders out, I leave all of the feeder holes open so the birds can drink without searching for which port is available.

Another aspect of my backyard bird photography that contributes greatly to the quality of the images is my practice of keeping the bird-feeders that I use as clean as possible, so that they work as props in the photographs. Keeping the feeders clean and, in fact, the entire garden in proper shape requires some time and planning. For instance, every time the oriole visits the feeder, he may spray some of the sugar water on the feeder as he drinks, so after he flies off, I go out and wipe off the drops of sugar water. In addition to dish towels, I use cotton T-shirts and old socks as rags. The T-shirts don't seem to leave lint on the feeders, and the socks are useful for cleaning the patio of small areas of dirt and bird droppings (of which there aren't many) and drops of sugar water that fall when the oriole feeds or when I move the oriole or hummingbird feeders around. I also hose off the patio on a regular basis. When I take photographs of the entire garden, I try to clean off not only the feeders but the birdbath and the patio as well. It's almost like being a set designer for a stage production, which is really what backyard bird photography can become. The birds are the stars, and I am the stagehand and perhaps the director of my own little play.

Photographing birds at the birdbath presents its own set of challenges. If a bird is standing or sitting in the water, you can photograph him at a lower shutter speed and lower ISO, but if the bird is drinking or bathing, it is best to shoot with a higher shutter speed and ISO, in order to stop the action. Try to use the Spot AF on the eye at all times, as a sharp eye will produce a satisfactory image, even if other parts of the bird are blurred because of movement. It is a challenge to catch a bird just as he is flapping his wings in the water, causing the water

to fly all about. If you can fill the frame with these droplets of water while keeping the bird in focus, you will produce a dramatic and aesthetically pleasing birdbath photograph.

As far as cleaning the birdbath is concerned, I brush off the concrete each day and add new water to the bowl a few times during the afternoon. There is nothing worse than having a bird land on the birdbath and discovering through the lens that there is a leaf or a piece of dirt in the water. Remember, the birds are bathing in this water as well as drinking, so the cleaner you keep your birdbath, the more prone the birds will be to use it, and the better your photographs of birds in the birdbath will look. I also clean off the leaves on the plants behind the birdbath to be sure that there aren't any bird droppings that would produce distracting patches of white in the backgrounds of the images.

Although most of your backyard bird photography will take place in bright sunlight, there may be times when you have to photograph in low light. Increasing the ISO on your camera will make your sensor "faster" and allow you to shoot at higher shutter speeds than with a lower ISO. In addition, you can use the exposure compensation feature on your camera in increments of 1/3 in order to brighten up your image, as the camera automatically increases the size of the aperture or slows down the shutter speed to allow more light to hit the sensor. Be careful that your shutter speed isn't reduced so much that you end up with a blurry picture.

Late one afternoon in Vermont, one of the bee balm patches in the garden had just gone into a semi-shaded state, and at that very moment, a Ruby-throated Hummingbird decided to visit the bee balm at this very spot. I had to act fast and I increased the ISO on the camera to 3200, and even then I was only able to photograph the hummingbird at 1/800 second at f/9. One of the images I took shows the hummingbird approaching the bee balm flower head. While the original image was a little dark, I was able to brighten it up with image editing software. In between shots, I used the LCD screen loupe to review the photographs I had just taken, so that I could make adjustments to the ISO settings.

During the winter in Los Angeles, the American Robins visit my birdbath every day at about 7:00 a.m. before the sun has risen. On one of these occasions I set the ISO at 800 and captured a robin squawking at another robin as he marked out his territory on the birdbath. On another occasion, when the Hooded Oriole was taking a bath in the partial shade, I increased the ISO to 1600 in order to make sure that I could shoot at a high enough shutter speed to get the bird's eye and beak in focus as the drops of water flew all around him.

Sometimes, when your subject has a bright or dark area behind it, you might want to use spot metering instead of evaluative metering. This means that the camera will take an exposure reading off of the bird, rather than off of the surrounding area. When shooting in evaluative metering with a shady bush in the background, the camera may think the scene is too dark, and your bird will be overexposed; and if you shoot into a bright sky, the camera may want to decrease the light going to the sensor and you will end up with a bird that is

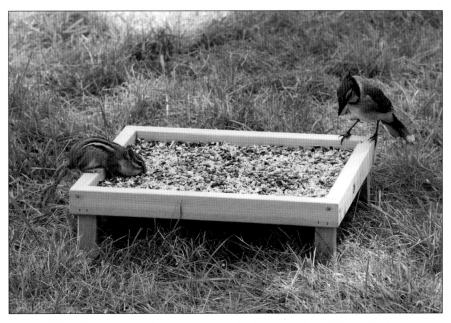

Blue Jay and eastern chipmunk at ground platform feeder

too dark. Spot metering is designed to compensate for these conditions so that the exposure is correct for the bird itself. In the case of a light-colored bird, spot metering may help you trick the camera into "stopping down" (i.e., using a higher f-stop) so that the bright feathers are not too bright. However, spot metering can make the camera overcompensate, resulting in an image that is too dark. Therefore, it's a good idea to "bracket," meaning taking a number of exposures at different settings until you figure out which ones work best in any given situation. If you don't have time to analyze these differences while you are shooting, you can compare them later and pick the best exposures from the group, but at least you have a variety of exposures from which to choose. I have discovered, however, that photographing in evaluative mode produces satisfactory results in most instances, and I have learned to trust the camera rather than try to outthink it. In evaluative mode, you can bracket by using exposure compensation either brighter or darker than the settings that the camera produces automatically.

While backyard bird photography involves a large number of predictable occurrences with its usual cast of characters, I always have to remind myself to be prepared for the unpredictable. Just as I think I am going to photograph the Scrub Jays alone, the Nanday Parakeets fly into the avocado tree above the garden, begging for my attention. Should I stand my ground and photograph the jays at close range, or pull back a bit to allow the parakeets to fly down and take over the feeder, as they will not allow me to photograph them from as close as the jays do?

Then there are the times when I'll be photographing at the birdbath and I'll hear a plunk on the green platform feeder, look over and see a California Thrasher, or even a Band-tailed Pigeon. I then swivel the camera on the tripod in order to catch this bird before he flies off. The birdbath itself has produced many surprises, such as the day when the Hermit Thrush and Yellow-rumped Warbler shared a drink together or when the Western Tanager stopped by for a few sips on his only visit to the garden. I have looked over at the green platform feeder many times expecting to see a Scrub Jay or House Finch, only

to observe a Black-headed Grosbeak or an Oak Titmouse. Knowing that these are fleeting moments throws me into a tizzy, but I try to gather myself together to produce a good photograph of one of these sporadic visitors.

This is especially true of the woodpeckers that visit my garden, which include the Nuttall's Woodpecker and the Acorn Woodpecker. Since the woodpeckers are usually perched in a tree about fifteen or twenty feet away, I use a low ISO setting as I plan to crop the image in order to enlarge the bird. This technique has worked on a number of occasions.

In addition to the birds, there are some other animals that like to eat my birdseed and peanuts. In Los Angeles, the California ground squirrel will eat the birdseed off of the ground or from a ground platform feeder, but for some reason, he will not jump onto the green platform feeder on the pole when it is more than two pole sections off the ground. I shoo the squirrel away when I'm photographing the birds at the ground feeder, but he often returns after a few minutes. Eventually, he gets his fill and disappears for a while, so I can concentrate on the birds. It is amazing to see how the birds and the squirrel coexist peacefully, feeding side by side, as the squirrel never thinks about attacking a bird. The squirrel also likes using the birdbath for drinks of water.

In Vermont, I have to contend with not only the red squirrel but the chipmunk. Both of these animals take the birdseed and peanuts from ground platform feeders and from the platform feeder that I place on a low table. The red squirrel will climb up a tall pole to get the birdseed or peanuts from the green platform feeder, while the chipmunk cannot jump from the pole up onto the feeder.

The chipmunk is hysterical to watch as he gathers peanut after peanut from the platform feeder on the table, and then returns to his den to store these peanuts for the winter. I watch him as he returns to the den, first hopping off the feeder and table, then crossing the driveway, then running through the flowerbed and up the hill, only to disappear into the shrubs where I presume his den is located. A few minutes later, I see movement in those shrubs, then through the flowerbed, and the chipmunk appears again running across the drive-

way and jumping up onto the table and then onto the platform feeder for another peanut. I usually coax him off the feeder gently, as I want the peanuts to remain in place for the Blue Jay, who may arrive at any moment. Since I have positioned the best-looking peanuts on the platform feeder in just the way I want them to look, I know that after the chipmunk has taken his peanut, I will have to rearrange the peanuts to make sure that they all look good in case the Blue Jay chooses any area of the platform feeder to perch and the peanuts end up in the shot. But the chipmunk is so amusing that I often let him have a few peanuts and even take a few photographs of the little fellow, just for fun.

Sometimes the chipmunk is so distracting that I put a dish towel over the wood platform feeder, but the chipmunk has learned how to crawl up under the towel and retrieve the peanuts. Nevertheless, the towel is often enough of a deterrent for the chipmunk to keep him away for a little while. Then, if I hear the Blue Jay approaching with his squawks of arrival, I take the towel off of the platform feeder and wait for the jay to fly down for a peanut. After the jay has left, I can put the towel back on the feeder and return to my hummingbird photography, as I often work on the hummingbirds and fit in the Blue Jay shots by swiveling the camera to the left and catching the Blue Jay at the platform feeder. The Blue Jay visits are so sporadic that to wait there all morning just for a Blue Jay visit would take too much time away from my hummingbird photography. If I really want to concentrate completely on the hummingbirds, I have to take the wood platform feeder into the house and forego any Blue Jay visits that might occur during that shooting session. It's either that or allow the chipmunk to take away as many peanuts as he can while I am photographing the hummingbirds, and this is distracting enough in itself.

On one occasion, I discovered the chipmunk and the Blue Jay feeding together on the mixed birdseed at a ground platform feeder. This was a nice moment, and I was fortunate to get a photograph of it. Perhaps this is the reward of backyard bird photography, to capture images of different species, whether bird or otherwise, sharing the same space.

As you explore bird photography in your own backyard, you will encounter numerous challenges and opportunities for producing wonderful images. I hope that the techniques that I have described in this chapter will help you in your quest to produce great bird photographs.

Lesser Goldfinch

Photographing Birds In My Garden

"It is easy to understand why so many of us are so fond of birds. They are lively; they are lovely; and they are everywhere."
—David Attenborough, *The Life of Birds*

My garden in Los Angeles contains an assortment of flowers and shrubs that grow in an area to the side of a brick path. Within this area, I can place birdfeeders to attract whichever birds I want to photograph at any particular time.

The flowers include bird of paradise, fuchsia, bottlebrush, and Mexican sage, on which the hummingbirds feed. Then there's the birdbath, which attracts all kinds of birds to drink and bathe. The shrubbery shelters the birds and they emerge from the bushes to approach the birdfeeders. I sit or stand in the middle of all this, watching the activity and waiting for my opportunity to take a great bird photograph.

I encourage everyone to develop an oasis such as this, where you can replenish your soul and provide support for the wildlife in your area. The rewards continue every day, as I observe how my efforts to offer a good environment for the birds has resulted in a rich daily experience of interactions with these fascinating creatures. In one afternoon, as I photograph the Allen's Hummingbird, I may also watch the California Towhee hop around on the patio waiting for his peanut kernel, marvel at the Hooded Oriole flying to his oriole feeder from the palm tree one hundred feet away, listen to the Northern

Mockingbird calling from his perch in the oak tree, see the Scrub Jays fly into the avocado tree as I put some birdseed out for them on the platform feeder, witness the Nanday Parakeets landing in the same tree and screeching away before they fly down for some birdseed, and watch a Red-tailed Hawk fly overhead. Indeed, the garden is a constant flurry of activity, always changing, always bringing a new surprise to delight me.

Since most of my photography takes place in the afternoon, the Scrub Jays always arrive at this time to see what foraging opportunities are available. Usually, I put out birdseed for them, but if I want to photograph them with peanuts or other items in their beaks, they are more than happy to cooperate, and as long as I put out food for them, they will continue to take it.

My favorite technique for Scrub Jay photography involves placing the food items, be they peanuts or otherwise, on a platform feeder that is placed on a pole. I position the camera six to eight feet away, and try to capture an image of the bird with a peanut in the beak, or just a

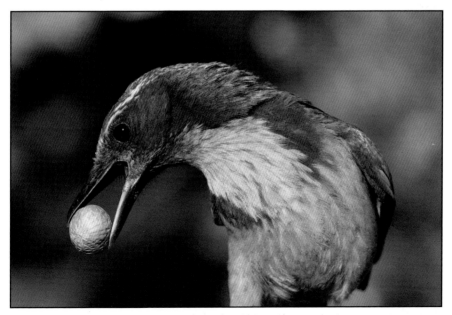

Scrub Jay with peanut

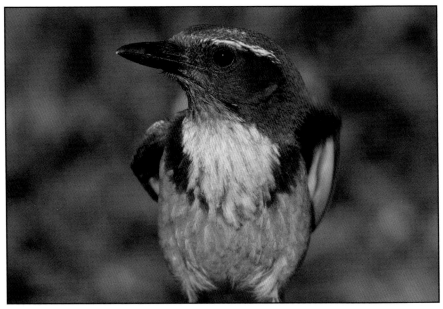

Scrub Jay portrait

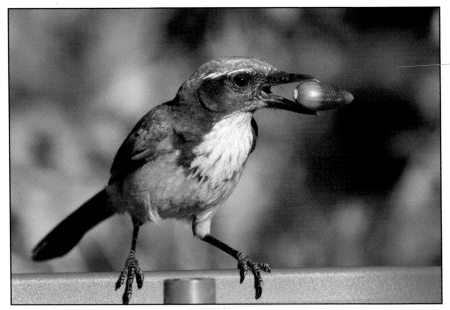

Scrub Jay with acorn

portrait without any object in the beak. I try to anticipate exactly the moment when the bird will turn his head for a good profile, or perhaps when he is looking in my direction. It all happens in a few seconds between when the bird lands on the feeder and he flies off.

Believe me, you have to be alert and act fast. Sometimes the bird swoops down and picks up the peanut in one motion, causing me to miss the shot. Sometimes the bird turns his head away from me, and I lose another opportunity. It may take fifty peanuts in order to get one or two good shots, but I persevere and try to outlast the birds.

I am always looking through the camera before the bird lands on the feeder, so I have to pan over to find the bird, compose the shot, then press the autofocus button lightly, then click the shutter, all in a matter of a second or two, in order to get each shot. It's like an athletic event, with hand-eye coordination at a premium. But when I get a great Scrub Jay image, it's very rewarding.

Over the years, I have had a lot of fun with the Scrub Jays, and on a number of occasions I have created special scenarios for photographing them. The Scrub Jay is so named because of its predilection for inhabiting scrubby, brushy environments where the birds can be easily hidden in the foliage for their nesting and roosting. Meanwhile, they feed on the acorns on the oak trees that grow throughout their range.

In my neighborhood, the coast live oak is the primary oak tree, and it produces acorns in September. Occasionally I gather up these ripe, brown acorns myself, either from the tree or after they have fallen to the ground. Then I bring a whole bunch of them back to my garden, place them on the platform feeder, and try to get a photograph of a Scrub Jay with an acorn in his beak. This is the most natural view of all, even if it's composed in a preconceived manner.

But perhaps the most fun I've had photographing the birds in my garden occurred in 2005, when I conducted an experiment which I called the Scrub Jay Potluck. I placed a variety of food items on the platform feeder, including the following nuts: peanuts, cashews, almonds, pecans, hazelnuts, and pine nuts. To this I added small cubes of cheddar cheese, along with red and green grapes. Next, I added Goldfish crackers, cheese crackers, pretzels, breakfast bars, Fig

Newtons, donuts, donut holes, brownies, and chocolate chip cookies. I placed the platform feeder on the grass to take a photograph of the items before I offered them to the Scrub Jays. Then I attached the feeder to the pole, moved back a short distance, got behind my camera, and waited for the Scrub Jays to fly down onto the feeder and choose their favorite foods.

Which item would the Scrub Jays take first? The peanuts, of course. Then they took the cashews, the Goldfish crackers, and a donut hole. They generally took the nuts first, but they went crazy for the chocolate chip cookies, brownies, and donuts as well. You see, the Scrub Jays have a sweet tooth. In order to hold the donuts, brownies, and donut holes, they pierced the item with the top and bottom tips of their beak and flew off carrying the whole thing. It was pretty comical watching them fly off with an item the size of their heads. They took the cheese and the grapes last, but I got photographs of every food item in the jays' beaks. If you consider that the corvid family (which includes

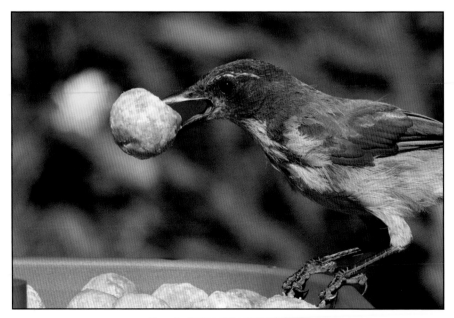

Scrub Jay with donut hole

Scrub Jays as well as ravens and crows) will eat almost anything, it's no surprise that the Scrub Jay has eclectic tastes in food.

I don't recommend feeding human food to birds, but I do it on rare occasions for the experiment and to get a neat shot. By the way, the California Towhee and California Thrasher, in addition to the Scrub Jay, love Cheerios.

In the past, I hung my hummingbird and oriole feeders from a stationary pole that I pressed into the soil, but in recent years, I have also been using a pole mounted on a circular base so I can move the pole around to different areas, depending on which backgrounds I want to use. I attach a long arm to the pole and then hang the feeder from this arm, so that the feeder is far enough away from the pole that the pole won't get in the shot. (In the case of the oriole feeder, I sometimes attach a second arm so that the oriole can perch on this arm just before dropping down to the oriole feeder, but it isn't really necessary. The oriole is happy to perch on the main arm before approaching the feeder.)

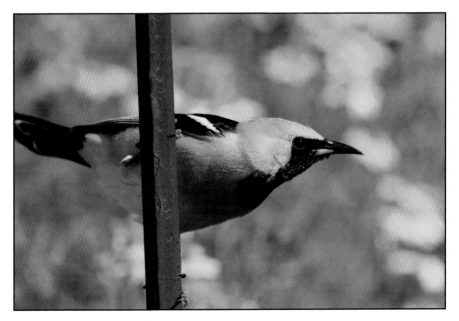

Hooded Oriole on pole

In addition, I can attach these arms as high or low on the pole as I want, so I can control not just whether I have a yellow background from the bush daisy flowers, but what the composition of this background will be. I have to experiment with a few placements of the arm until the right combination of yellow flowers and green leaves give me a pattern that I find pleasing for the background. This pattern can also be controlled by moving the camera higher or lower on the tripod. A combination of both of these techniques will give me the background that I want. This preparation is invaluable when the hummingbird flies into the frame and he's just where I want him to be, with his head in the green area between two patches of yellow.

If a hummingbird starts feeding on the bottlebrush in the corner of the yard, I quickly change the setting of the camera from 1/500 second in shutter priority to 1/2000 second, and I change the ISO from 400 to 1600 or 2000. Then I lift up the tripod and camera and approach the bottlebrush. I raise the camera higher on the tripod, straighten the lens, and try to capture the hovering hummingbird as it drinks the nectar from the bottlebrush flower.

When I return to the hummingbird feeder, I have to change the settings back, lower the camera on the tripod, straighten the lens again for this setup, and recompose the shot to get the same background that I had before. During a few hours, I might go through this procedure four or five times, in order to get the feeder and flower shots that I want with the hummingbirds.

As I mentioned earlier, back in 1997 I photographed the Hooded Oriole at the lemon tree on the canyon side of my pool from about ten feet away, but it took me a few months before the oriole would let me get close enough to take that shot. Because the oriole is so wary, I developed a technique of photographing the oriole from inside the house, through an opening in my sliding glass window. This has served me well for close-up images of the oriole with the yellow flowers of the bush daisy in the background.

When I am using the garden to photograph other birds, I place the oriole feeder on a stationary pole on the canyon side of the pool. (The lemon tree is no longer there.) Usually, in the past, the oriole flew off of this feeder if he so much as saw me across the pool, but for some

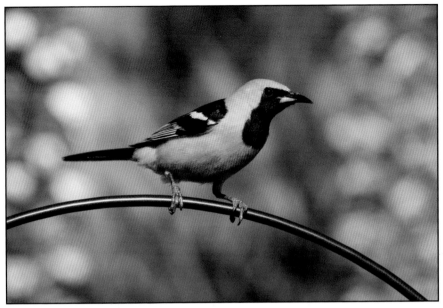

Hooded Oriole on feeder pole arm attachment

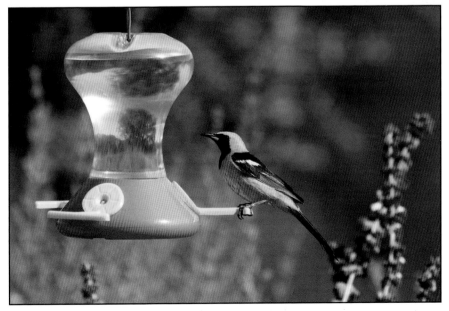

Hooded Oriole with feeder and Mexican sage

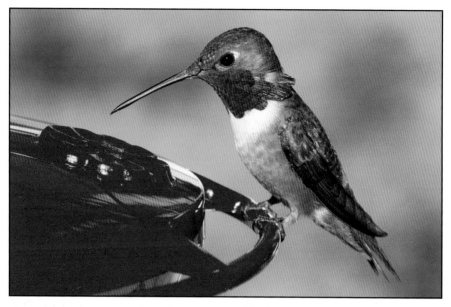

Allen's Hummingbird profile

reason, in the spring of 2013, he remained on the feeder more often than before. So I decided to try and photograph him on the far side of the pool, and lo and behold, he stayed put . . . at fifteen feet, at twelve feet, at ten feet, and at nine feet, over a number of days, one day for each distance as I got closer and closer.

Not only that, but he made a succession of visits throughout each afternoon, from 3:30 or 4:00 p.m. until 6:00 or 6:30 p.m. He chuck, chuck, chucks from his perch in the coast live oak tree on the canyon side of the yard. He whistles to his mate in the palm tree down the hill about sixty feet from this side of the yard. Then, suddenly, he's airborne, perching on a nearby pole that I leave for this purpose, then he flies to the pole from which the feeder is hanging, and presto, he's on the feeder—all in a matter of seconds. I have to react quickly to compose, focus, and click the shutter during his visits of ten to fifteen seconds, with his head bobbing up and down as he plunges his beak into the feeder hole, then turning from side to side as he surveys the area. Then he flies off the feeder over the other side of my yard toward the street or back to his palm tree.

One day, I decided to try and get an image of the oriole while he was clinging to the feeder pole, and I had to guess which side he would be facing so that I could use the Spot AF point on that area. When he landed, his head appeared in that exact area of the frame, and I pressed the shutter lightly to autofocus, then down to activate the shutter. I was aiming for a composition of the yellow and black of the oriole with the background of the golden Mexican marigold, and it worked. Was that luck or a matter of preparation? Perhaps a combination, but I like to think that the harder I work, the luckier I get. On another occasion, while shooting from the blind inside my house, I took a photograph of the Hooded Oriole as he perched on the arm attachment to the feeder pole, just before he dropped down onto the feeder. This was a good opportunity to get a portrait of the entire bird.

The canyon side of the yard also worked very well for photographing the Black-chinned Hummingbird and Allen's Hummingbird with the Mexican marigold in the background. At the same time, if the hummingbird flew over to the Mexican sage flowers right next to the feeder, I could change the settings on the camera and try to capture one of the hummingbirds while it was feeding at the Mexican sage. It was very productive to use both the feeder and the flowers alternately during the same afternoon.

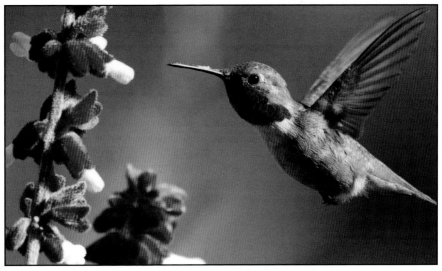

Allen's Hummingbird at Mexican sage

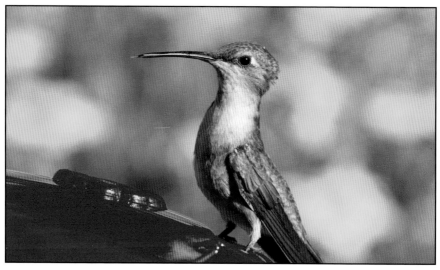

Black-chinned Hummingbird female and Mexican marigold

The setup for hummingbird photography in the main area of my garden is rather simple. I place my camera about six feet away from the feeder (as close as the Canon 100–400mm lens will focus), positioning the tripod on the patio or on the flat stones in the flowerbed area of the garden, and not on the soil, so the legs will be stable. I have also used flat pieces of wood on which to place the tripod legs so they don't sink into the ground. With this setup, I can change the location of the feeder hole by turning the top portion of the feeder, depending on whether I want a profile of the bird or a head-on shot.

I am very happy with my hummingbird profiles, but I have recently become interested in hummingbird portraits where the bird is facing the camera, either to the left or right of the hummingbird feeder's hook, which I can crop out of the photograph. When the Allen's Hummingbird is facing me, I can catch the bright orange-red color of the hummingbird's gorget when the sun hits it at just the right angle. How much of the bird's body appears in the shot depends on where the bird plants his feet when he lands on the feeder, either to the side of the feeder hole or behind it. Also, the reflection of the bird on the red surface of the feeder creates an extra element.

When I frame the image in the viewfinder, I am always thinking about the finished product. I use the second Spot AF point from the

top, so that the hummingbird does not appear too low in the shot with a lot of empty space above him. In addition, placing the bird's head in the top third of the frame allows me to get the rest of his body into the shot.

In my yard, the resident Allen's Hummingbird chases all other hummingbirds out of the garden, whether they are visiting the flowers or they are trying to use the feeder. It's amusing to watch him escort these interlopers out of the yard. He often sees these other hummingbirds before I do, and he buzzes in at them with a metallic sound to his wings, following them until he disappears either down toward the canyon or onto the adjacent property.

While the Allen's Hummingbird spends most of his time guarding the main area of my garden from other hummingbirds, he cannot cover every part of the yard. As a result, the Mexican sage on the canyon side of the pool gives me an opportunity to photograph other Allen's Hummingbirds, the Anna's Hummingbird, and the Black-chinned Hummingbird. After photographing in this area for a while, I noticed that a male Allen's Hummingbird would perch in the coast live oak tree on the canyon side of the pool and he would chase off

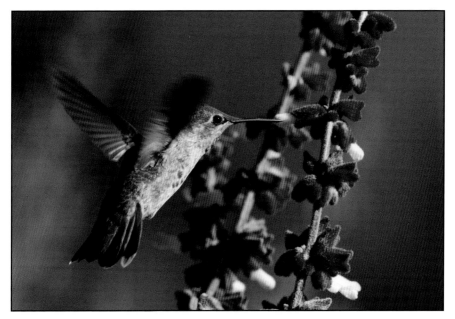

Anna's Hummingbird at Mexican sage

the other hummingbirds from the Mexican sage in this area. Was this the same male that I knew from the primary area of the garden? One day, I walked back to the primary area while I saw that this male was in the oak tree, and there was my original Allen's Hummingbird male perched in the flowering plum tree, watching over the main part of the garden. Thus, two male Allen's Hummingbirds were patrolling different areas of the yard, as my original male had to relinquish some control over one section of the yard, at least for part of the time.

Whenever a different hummingbird—other than either of these adult males—lands on a hummingbird feeder or hovers near the Mexican sage or another flowering plant, I am on guard that at any moment the male Allen's Hummingbird can buzz the hummingbird that I am trying to photograph and drive it out of the frame of the viewfinder, if not out of the yard entirely. These are tense moments, and I have to act fast to capture images sometimes, knowing that my activity can be interrupted by the forces of nature at any time. But this is part of the challenge as well.

I normally do my hummingbird photography in the main portion of the garden, and I am used to the resident male being the lord of his manor in this part of the yard. But that doesn't mean he will visit the hummingbird feeder whenever I want him to. One day, I stood in front of the hummingbird feeder for a couple of hours, and for some reason the Allen's Hummingbird didn't visit the feeder at all. He chased a few hummingbirds out of the yard, went to the bottlebrush a few times, but he didn't go near the feeder. Behind me, the Hooded Oriole kept making visits to the pole on which his oriole feeder should have been hanging. But when I photograph the hummingbird for a couple of hours on the afternoons when I work on the hummingbirds, I take the oriole feeder down and place it on the patio table where I keep some of my birdfeeding supplies. This is because the humming-birds may use the oriole feeder and I will miss an opportunity to pho-tograph them at the hummingbird feeder. Sometimes the oriole flies over to this table and tries to drink from the feeder there. But most of the time he makes a lot of noise from his perch in the oak tree on the canyon side of the yard or on top of the feeder pole, telling me to get that oriole feeder back where it belongs.

Well, on this occasion, I turned to look across the pool at the oriole, perched on the pole, and I noticed that the Mexican sage below him looked really beautiful as it was backlit against the late afternoon sun. What if I went over there and tried to photograph a hummingbird as he was backlit while feeding on the Mexican sage, I wondered. So I abandoned the hummingbird feeder and carried my tripod and camera over to the far side of the pool.

Now, the late afternoon is a very busy time for hummingbirds as they try to drink up enough nectar to make it through the night, so I had numerous visits of hummingbirds to these flowers. I had to pan along with the movement of the hummingbirds, trying to focus on the hovering bird and click the shutter before he moved on to his next blossom. In situations like this, don't be afraid to keep shooting. You'll miss most of them but if you catch one in focus, it will make up for the misses. This is exactly what happened to me. Every shot during this session was either out of focus or badly lit. But the last picture that I took that afternoon captured the hummingbird with his wings outspread as he was positioned against a stalk of Mexican sage.

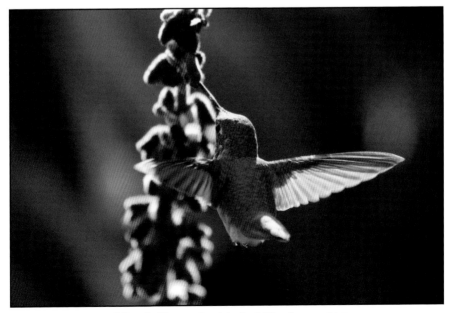

Allen's Hummingbird at Mexican sage

What are the lessons here? Keep your eyes open for opportunities in your garden that may present themselves when you least expect them. Then, when you get these chances, act immediately. Sometimes I am so dumbstruck by a bird that lands in the yard that I just observe it for a few moments, then realize I better hop into action and get a photograph, but by then it's too late. He's either moved from his original position or flown off. Keep in mind that even under the best of circumstances, you have to take a lot of photographs in order to get a good one, so don't worry if you keep taking shots that don't work. Eventually, you'll hit on the right moment and everything will fall into place. I live for such moments.

Remember, as well, that you may be waiting for a long time in your garden and it seems as if nothing is happening, and then suddenly you will get a chance for a great image. Either an unexpected bird will fly into the yard, or the one you have been waiting for at just the right spot will actually appear in that exact place where you have your camera positioned. It's amazing that from one moment to the next, a backyard bird photographer can go from despair to exhilaration, merely by the chance of the moment. But it's when preparation meets opportunity that most of my best backyard bird photographs are produced. So I try to hang in there until the day unfolds and I have taken advantage of every opportunity to get a great bird photograph. Usually this means waiting until the light just starts to turn darker at the end of the afternoon. You can tell when you lose that extra brightness to the light and the day is done. Then I pick up the tripod and go back into the house, replace the shooting feeders with my spare feeders, and get ready to download and edit the photographs. Since I've usually been on my feet for well over two hours, I am glad for the chance to sit down at the computer and have fun looking at my bird photographs and trying to make them even better with the editing software.

Whether I am in my garden in Los Angeles or the one in Vermont, I listen to the birds around me. This gives me an idea of what to expect before I even see certain birds enter the yard. In Los Angeles, for instance, I know if there is an Allen's Hummingbird flying

nearby from the metallic sound of his wings, and I can distinguish the light peeping of the Black-chinned Hummingbird's voice and the mild buzzing of his wings before I even see him. I hear the cheep of the House Finch in the nearby tree, the shrieking of the Scrub Jays as they prepare to feast at my platform feeder, and the soft whistle of the Hooded Oriole from his nest tree down the hill. I hear the screeching of the Nanday Parakeets down the street from me as they get ready to fly over my yard, and I prepare myself to try to get a photograph of the flock as it flies overhead. A few of the parakeets will no doubt break off from the pack and land in the avocado tree before descending to my platform feeder for some sunflower seeds. Meanwhile, the California Quail produces his soft, guttural call from down the hill

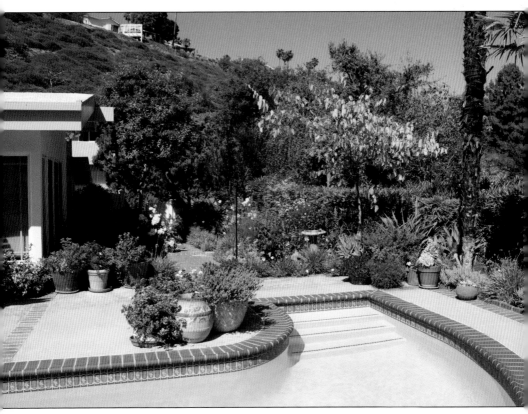

**View of main garden side of pool in Los Angeles,
with hummingbird feeder and birdbath**

as he makes his way into the yard. I have heard him in advance, so I am ready for his arrival. All of these noises alert me to the possibilities of the afternoon's shoot. In a way, I can often make my selection of activities based on the sounds that I hear in advance of the arrival of the birds.

My garden in Los Angeles has sunlight most days of the year. As long as I keep birdseed and sugar water in the birdfeeders, and water in the birdbath, the birds will arrive every day, throughout the day. I look forward to each of my photography sessions with these birds, and I sometimes find it difficult to decide which bird to photograph on any particular day.

I usually photograph a certain bird with a particular background until I feel that I have enough images of this type that I can move on to another setup. It's mostly instinctive. I can just feel that I've taken enough photographs for now of, say, the Hooded Oriole from the blind, or the Scrub Jay with a peanut in his beak, or the hummingbird on the feeder. So I move on to another opportunity, always changing, always trying to keep it fresh.

My garden is not very large, but it is a good example of what you can do in a city environment. Most days of the year, ten to fifteen species of birds may visit the garden. I always look forward to returning to this little oasis, whether I am running errands around town or returning from a long trip. When I'm away, I really miss the Scrub Jay, Allen's Hummingbird, and Hooded Oriole, and I can't wait to get back home to hang out with these birds and to photograph them.

You can do the same thing in your own garden, as the birds become part of your extended family.

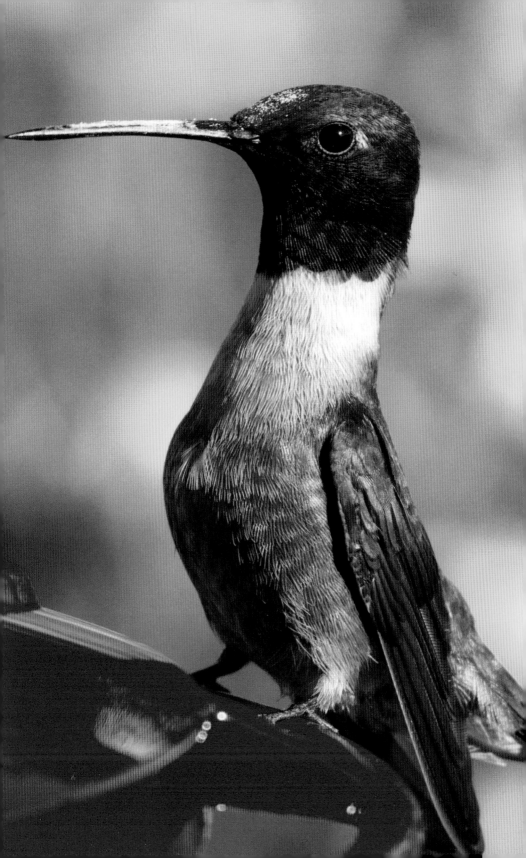

Ruby-throated Hummingbird

8

Photographing Birds In a Vermont Garden

"The jays take what they can. . . . The table is set for them, I say; and they seem to know it. They come not as thieves, but as invited guests, or, better still, as members of the family."

—**Bradford Torrey,** *The Clerk of the Woods*

In the summer of 2012, I spent five weeks photographing the birds in my garden in Adamant, Vermont, a tiny hamlet about seven miles outside of Montpelier. The house is situated on a dirt road, facing northeast. A strip of lawn runs across the length of the house in the front yard, bordered by a wood picket fence.

As the sun rises in the morning, it throws light on the area of the garden by the driveway, and in the afternoon the sunlight falls on the eastern side of the yard. These two spots became my staging areas for the hummingbirds in the morning and the songbirds in the afternoon.

When I arrived in late June, the garden was empty. I took a feeder pole out of the garage and stuck it in the ground near the driveway, then filled up a hummingbird feeder with sugar water and hung it from one of the arms on this pole. I then went down to the garden center and bought a Nyjer seed tube feeder for the American Gold-finch, along with bags of Nyjer seed, mixed birdseed, and black oil sunflower seed. Next, I went to the supermarket and bought a few bags of unshelled, unsalted, roasted peanuts for the Blue Jays. When I got back, I put mixed birdseed and peanuts into a wood platform feeder and put the feeder on top of an upside-down flowerpot, so I would have some peanuts available until I put a pole in the ground

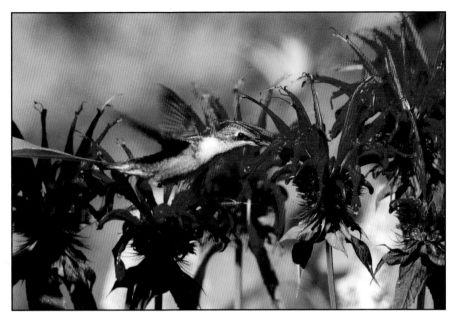

Ruby-throated Hummingbird at bee balm

for the green platform feeder that I use for this purpose. Sure enough, a Blue Jay dropped down and took some of the birdseed and peanuts from the feeder. I clicked off a shot of him as he perched on the rim of the feeder with a peanut in his beak, just before he flew away.

The following day, I put the Nyjer seed feeder up with the hummingbird feeder, on opposite arms of the same pole next to the driveway. I was hoping to photograph either the Ruby-throated Hummingbird or the American Goldfinch, depending on which feeder had a bird on it. This way, all I had to do was pan the camera either right or left to catch a bird on whichever feeder it was on. This proved to be more ambitious than it was worth, as I found myself having to recompose for either a hummingbird or a goldfinch, and often I couldn't catch up with either bird. However, that morning I got a neat shot of a Ruby-throated Hummingbird hovering over the feeder, and the following day I captured the American Goldfinch.

In the meantime, I placed the wood platform feeder onto a patio table that I could put in the driveway in the morning and then move

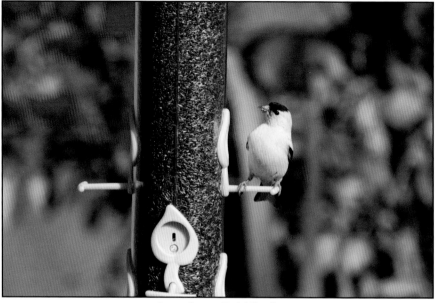

American Goldfinch

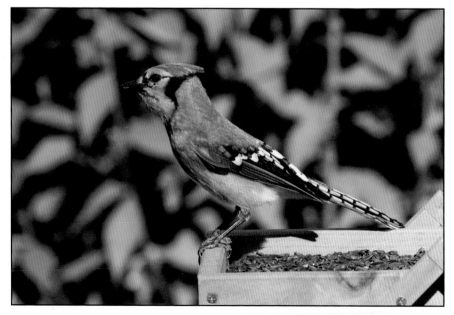

Blue Jay

to the eastern side of the yard in the afternoon. I filled the feeder with black oil sunflower seeds, so if a Blue Jay flew down to get some sunflower seeds while I was photographing the hummingbirds, I could just pan the camera to the left and photograph the jay, then go back to the hummingbirds that were right in front of me. As it happened, the Blue Jay visited the garden in the afternoon and I got a shot of him as he stood on the rim of the feeder with the sunflower seeds beside him.

The next day, I stuck a pole in the ground in the center of the yard and hung the Nyjer feeder from this pole. I took off one of the arms of the hummingbird feeder pole and hung the hummingbird feeder from the remaining arm. Now, I could photograph the hummingbird on either side of the pole by just moving the feeder arm into its slot on the top of the pole on one side or the other.

It was great to be able to concentrate on just the hummingbirds in the morning, although I couldn't resist putting out the wood platform feeder in the driveway just in case a Blue Jay dropped by (hopefully during the periods between hummingbird visits). I got one comical shot after I placed a plastic food container with birdseed on the table and, as it happened, a Blue Jay perched on the edge of this round dish and ate the birdseed. I then replaced the container with the wood platform feeder holding peanuts, and the jay came down for a peanut. I caught him just as he flew off of the feeder with a peanut in his beak.

The goldfinches soon got used to the new location of the Nyjer feeder, and they perched on a utility wire above the yard or in a tree across the road before they flew in to the feeder. They made little cheeps while they were up there. They were talking to each other, but I like to think that they were talking to me as well.

The American Goldfinch in Vermont is much more skittish than the Lesser Goldfinch in Los Angeles, and I couldn't get closer than about twelve feet to these birds without flushing them up to their wire or their favorite tree. Meanwhile, the Blue Jay did not visit the yard as often as I thought he would, even when a feeder full of peanuts sat there all day long. He would fly down, take a peanut, and then disappear into the woods. He did not arrive with a few of his cohorts and clean me out, as the Scrub Jays in Los Angeles do. At the same time, the hummingbird, which I expected to visit the garden on rare and

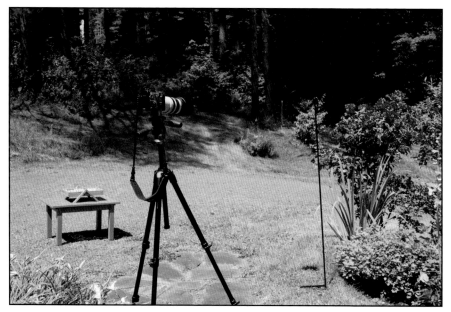

Morning area in Adamant, with camera, hummingbird feeder, and wood platform feeder with peanuts

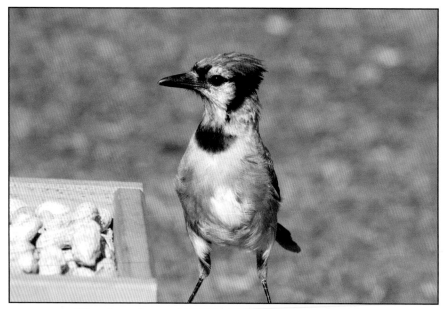

Blue Jay at wood platform feeder with peanuts

brief occasions, fell into a routine of using the hummingbird feeder every twenty minutes or so, all day long.

I usually photographed him from about 7:00 a.m. until noon. This was a great opportunity, and I jumped at it. The Ruby-throated Hummingbird exists only east of the Mississippi River, and I had more than a month with this marvelous bird all to myself. I made sure that I didn't miss a morning session with that hummingbird.

After a while, the hummingbird got used to me, although it was rare for him to perch on the feeder when I was really close. As explained earlier, I started photographing this hummingbird with a 100–400mm lens, and then I moved in with a 180mm macro lens equipped with a 1.4x teleconverter.

Sometimes the hummingbird would make an approach just when I made a movement, and then he would veer off to a nearby tree to wait for another pass. I had to keep almost perfectly still for him to make it to the feeder, which he did bit by bit as he got closer, ever aware of my presence.

I had devised two background areas for this hummingbird shoot: the green grass across the driveway in the early morning, and the pink flowers of the rose bush in the late morning. In each of these cases, I had direct sunlight on my subject and the background, giving me the best chance to get a good photograph. Of course, hummingbirds drink the nectar of flowers, and in the afternoon section of the yard, two patches of bee balm offered me the chance to photograph the Ruby-throated Hummingbird among these plants. For some reason, the female went to these flowers, while the male used the hummingbird feeder more often.

In order to photograph a hovering hummingbird among the flowers, it is better to position yourself in front of that area and just wait for the hummingbird to fly in. On numerous occasions, I would be photographing the goldfinches at the Nyjer feeder, and suddenly the hummingbird would fly in to the bee balm patch just behind and to the right of the goldfinches. In my excitement, I would grab my tripod and take a couple of steps in the direction of the bee balm. No sooner did I do this than the hummingbird flew off. The only chance I had to approach this spot was when the hummingbird was feeding on

ABOVE AND BELOW: American Goldfinch

flowers closer to the ground, so she couldn't see me. By the time she moved up to the higher flowers, I had moved in a few steps. Later in July, after the bee balm flowers fell off, the hummingbird started visiting the lavender hosta flowers in the yard, but again, I only saw the female doing this.

Photographing the American Goldfinch posed its own set of challenges. While getting a portrait of a goldfinch on the Nyjer feeder was satisfying, the scene also amused me as other members of the group descended on the feeder and occupied each perch. The birds actually chirp at each other as they compete for these feeding spots, and capturing this interaction fascinated me.

One day, I stood in front of the Nyjer feeder and waited for the goldfinches to fly in. I could hear them chirping on the wire above me, and I held my ground until a female fluttered down and perched on the back side of the feeder. I had placed a white adhesive label over the feeder hole on the far side of the feeder, so the goldfinch could not get at the seeds unless she moved to a perch on the side or front of the feeder, where I could photograph her.

Well, this confused the little bird. She poked her head out from the right side of the feeder to see if I was still there. Then, she poked her head out from the left side of the feeder.

Finally, she gathered up her nerves and jumped over to the perch on the left side of the feeder. There she stayed until she had her fill of Nyjer seed, which took a number of minutes. I had a good time interacting with this tiny creature, and I was glad that she was able to trust me enough to come out into the open and let me take her picture.

If you put mixed birdseed in a platform feeder, the American Goldfinch will perch on the rim of the feeder when he arrives. This allows you to photograph the entire bird, including his feet, before he hops into the basin of the feeder. You can also take pictures of the goldfinch in the bushes or perched on a feeder pole. They don't perch very long, however, unless they are on a feeder. Then, they'll keep taking the seeds for a long time, giving you plenty of chances to get a good image.

In Vermont, the Black-capped Chickadee flies through the garden in the early morning and late afternoon. He always arrives

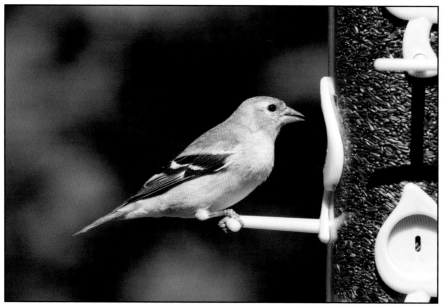

American Goldfinch

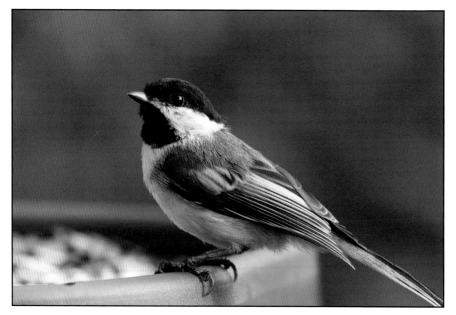

Black-capped Chickadee

with four or five of his friends and he flits over to the Nyjer seed feeder and grabs some seed, as the goldfinches do. But he also likes the birdseed in the platform feeder on the pole in the center of the yard.

It took me a while, but I finally got a photograph of the chickadee at this feeder in the early morning sunlight. His movements are so quick and his visits so short that it is extremely difficult to catch him while he isn't moving. For some reason, he never used the feeder during the middle of the day, but when I did see him he allowed me to photograph him from as close as six feet away with the 100–400mm lens, as his fear of me subsided with each trip to the feeder.

I really enjoyed listening to the call of that chickadee, but I couldn't figure out why this little flock of birds only spent a few minutes each day traveling through the yard, usually when the feeder was in the shade. They must have had better feeding grounds in the farmland that surrounds the Vermont house. If I had had more time, I would have placed the platform feeder on a pole in the hummingbird area, where I could position myself with a better angle for the morning sun, and photographed the chickadee there. But the hummingbirds were my top priority on this visit. Of course, after the hummingbirds migrated south in the fall, I would have been able to dedicate the driveway area to the songbirds. But, alas, these are the compromises you have to make with backyard bird photography. You can't photograph every bird all of the time, much as you would like to.

One day in late July, a small, brownish bird with a streaked chest appeared in the cherry tree in the front yard. This was a female Purple Finch (or a possible immature, as they look identical) that had observed the black oil sunflower seeds in the central platform feeder on the pole. I anxiously waited for her to fly down to the feeder, but she disappeared. I spent the morning photographing the Ruby-throated Hummingbird with the 180mm lens, and in the afternoon I found three of these Purple Finches on the platform feeder, along with an assortment of American Goldfinches. Since I didn't want to scare away the Purple Finches, I set up the camera and the 100–400mm lens just inside the front door of the house, thus creating a blind. It meant that I had to photograph from a greater distance than I wanted to, but

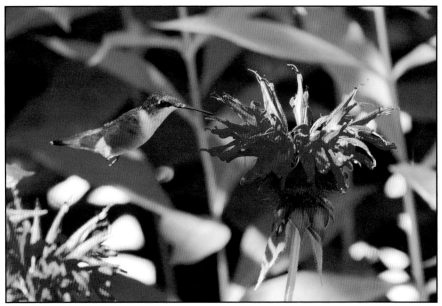

Ruby-throated Hummingbird at bee balm

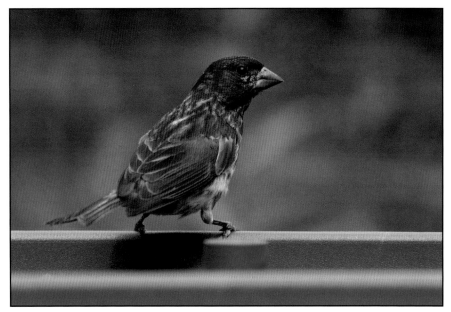

Purple Finch on platform feeder

I was able to show the entire feeder tray in the images, along with birds on each side of the feeder, or zoom in to show half of the feeder. The Purple Finches also went to the Nyjer feeder, along with the goldfinches, but they seemed to relish the sunflower seeds on the platform feeder.

The following day, the male Purple Finch appeared in the tree and took up residence in the yard. I really enjoyed listening to the warbling calls of these Purple Finches, and over the next few days, they allowed me to get closer to them as I photographed. Eventually, I got a very nice image of the male as he stood on the rim of the platform feeder, sporting his reddish-purple coat.

Unlike the other birds, I could not coax the Song Sparrow onto any birdfeeder whatsoever, and I had to resort to photographing him in the grass, where I had spread a small mound of mixed birdseed. The Song Sparrow in Los Angeles spends most of his time on the ground as well, but he will also use a ground platform feeder as well as the platform feeder on a pole. This Vermont Song Sparrow discovered the yard later in July, and he stayed along the perimeter of the grass, picking up seeds from the ground as they fell from the platform and Nyjer seed feeders. When I gave him a big pile of birdseed all to himself, he was in seventh heaven and he let me move in to about ten feet away as he hopped amid the grass for his birdseed.

And then there was the Blue Jay. It was like a cat-and-mouse game trying to photograph this fellow, as he managed to sneak into the yard when I least expected it. After a while, I realized that he often announced his arrival with a few squawks in the distance. When I heard this noise, I would prepare myself for his arrival. He would perch on the utility wire first, and wait until he thought I wasn't looking. I pressed my head up to the camera body and looked through the viewfinder, keeping perfectly still. Without a noise, he would appear in the frame of the shot and I would click the shutter. These were brief moments when he would alight on the feeder, grab a peanut, and fly off into the trees. He was not one to linger.

I took most of my Blue Jay photographs in between hummingbird shots in the morning, either by panning over to the platform feeder

View from morning area to afternoon area in Adamant, with humming-bird feeder in foreground, birdfeeders and camera in background

with the 100–400mm lens, with the camera mounted on the tripod, or, if I was using the 180mm lens on the tripod, I would handhold the 100–400mm lens that I had attached to a second 7D camera body, with the strap around my neck.

It was frustrating that the Blue Jay didn't stick around and take more of my peanuts, but I did the best that I could, considering how much effort I put into the hummingbirds. You have to learn to prioritize with backyard bird photography, if you want to get the best results. I would rather have more top-notch photographs of fewer species than a lot of merely good images of a wider variety of species.

While I was in Vermont, a number of other birds appeared in the proximity of the yard, such as the Red-breasted Nuthatch and Cedar Waxwing, but none of these species got close enough to the garden for me to get a good photograph of them. One bird, however, perched in a tree across the road one day in late July—a Cooper's Hawk. I was using the 180mm lens on the hummingbird at the time, but I took a few shots of the hawk in the tree with this lens, even though he was pretty far away.

A week later, I mistakenly left the metal platform feeder tray and the ground feeder tray with mixed birdseed overnight on the grass. (This is not a good idea in Vermont, as birdseed can attract bears to your garden.) Early the following morning, I looked out the kitchen window and saw the Cooper's Hawk standing on the grass next to the metal platform feeder tray, and he had a tight grip on a red squirrel, which had been tempted by the birdseed in these trays at that hour. I took a few photographs through the screen of the kitchen window of the hawk with the squirrel in its talons. Then, the hawk flew off with the squirrel. I was mad at myself for leaving the birdseed out overnight and I felt bad for the squirrel; but this type of predation could have occurred at any time.

As my stay in Vermont wound to a close, I began to reflect on all of the great experiences I had had photographing the Ruby-throated Hummingbird, Blue Jay, American Goldfinch, Black-capped Chickadee, and Purple Finch. As an amateur naturalist, most of my bird observations occur through the lens of a camera, and this visit to Vermont was no exception. Through my photographic activity, I became much more familiar with these species of birds than I ever had been before.

A few days before I left, as I explained earlier, I decided to display all of my birdfeeders in the afternoon area of the yard. I had the two platform feeders on poles, one with mixed birdseed and the other with peanuts; the Nyjer feeder on its pole; and on the grass, I had the wood platform feeder with peanuts, the wood platform feeder with black oil sunflower seed, the metal platform feeder with mixed birdseed, and the ground feeder tray with mixed birdseed.

Normally, I would not have this many feeders in close proximity to each other, as it would be difficult to predict which feeder would have a bird on it at any given time. It would also be hard to keep all of these feeders well-stocked with birdseed or peanuts, and to keep them clean enough to result in good compositions for my bird photographs, but I still enjoyed seeing them all together in one spot.

The day before I left, I took the two poles for the platform feeders out of the ground, so I had only the Nyjer feeder on its pole and the hummingbird feeder on its pole. I also left the wood platform feeder

Afternoon area in Adamant, with birdfeeders and camera, looking back at the hummingbird feeder and morning area in the distance

with sunflower seed and the wood platform feeder with peanuts on the grass in the afternoon area of the yard. That morning, I took my final photographs of the Ruby-throated Hummingbird and in the afternoon I took my last photographs of the American Goldfinch. That evening, I took the poles that held both of these feeders out of the ground and returned the poles and the feeders to the garage. I put away the wood platform feeders as well. The garden was now the way I had found it—empty.

I felt bad for the birds that I was leaving behind, especially the hummingbirds, who would have to adapt to life without the hummingbird feeder, but I had to return to Los Angeles and continue with my bird photography there. As I drove down the dirt road on the morning of August 1, on my way to the airport in Burlington, I felt a bittersweet tinge of regret that I could not spend more time with the Ruby-throated Hummingbird, Blue Jay, American Goldfinch, and Purple Finch, not to mention the chipmunk and red squirrel.

However, this sadness soon turned to the anticipation of seeing my old friends the Scrub Jay, Allen's Hummingbird, and Hooded Oriole in my Los Angeles garden. I knew that the Hooded Oriole would be around for only another month before it flew south for the winter, so as soon as I returned to Los Angeles I would grab my camera and try to get a few images of the juvenile orioles, which would no doubt be flying around the yard by now. While I was away, a friend had kept the oriole feeder stocked with sugar water, so I knew that the orioles would be in the garden waiting for me when I got home.

Allen's Hummingbird female with chicks in nest

⑨
Sharing Your Bird Photographs

"To be 'free as a bird,' untrammeled by petty cares, able to fly lightly over barriers and chasms that defy our plodding footsteps, is a way of living for which we sometimes yearn."
—Alexander F. Skutch, *The Minds of Birds*

So far in this book, we have discussed strategies and techniques for attracting birds to your garden and taking beautiful photographs of these marvelous creatures. But creating a work of art is an act of giving, so naturally, after you have produced a bird photograph, you will want to share this image with others.

Some of my best moments in bird photography have been to print out a picture at home and then show that print to a friend. The look on that person's face, whether it's joy or amazement, means the world to me. The circle has been completed, from conception to realization, to the viewing by an interested party.

In today's Internet age, the next logical step for sharing your bird photographs would be to post them on your Facebook page, or on another social networking site devoted to birds or photography. I also recommend starting your own blog, in which you can document your activities in your yard as you photograph the birds.

Depending on how ambitious you are with your bird photography, you can devote more or less time to these Web venues. However, a number of years ago, I was told by a top book editor that in order to establish a "platform" for your work, it is essential to have a blog. In publishing parlance, a platform is a base of followers that will trans-

late into sales of a book. With celebrities, a platform may be a hit TV show, or a smash record album, anything that draws a large audience to your work. We bird photographers must aim for less glamorous, if no less important vehicles for promoting our work and establishing our brand.

In my case, I began as a book writer who had some bird photographs published in one of his books, *The Hummingbird Garden*. However, when my bird photographs were not used in my book *Backyard Birdfeeding for Beginners*, I became a pure bird photographer until NationalGeographic.com gave me my column "The Birdman of Bel Air" four years later.

When that column ended in 2004, I tried to get my bird photographs published in book form, but I had no success. My platform was not large enough. However, in 2007, I became a contributor to VIREO (Visual Resources for Ornithology), a photo agency that has placed my bird photographs into numerous field guides and other birding books over the years. In that same year, I decided to focus on obtaining a gallery show for my bird images.

I remember walking into the James Gray Gallery at Bergamot Station in Santa Monica and trying to pitch gallery director Heidi Gray on my Yosemite photographs. Heidi didn't seem impressed as she looked at her computer screen. Then she continued the slide show and a few of my bird photographs popped up.

Heidi stopped the slide show and called over to James, who was sitting at his desk across the gallery. James came over and Heidi showed him my bird photographs. James was obviously impressed.

"I think we can help you," he said.

Thus began a ten-month process of preparing for my exhibition of twenty-five of my best bird photographs. This involved selecting the images, finding a printer, getting the prints framed, and then promoting the show with invitation cards that were sent to any and all prospective viewers.

Heidi gave me two pieces of advice about choosing photographs, and about why she gave me the show in the first place.

"People love color," she said. "And people will pay for what they cannot do themselves."

In other words, countless people take pictures of Yosemite and other popular landmarks, but how many photographers have the patience and the expertise to produce the bird photographs that I had already created by that time? This inspired me to think that all of those hours—indeed, years—in the garden and in various places throughout the world photographing birds had been worthwhile after all. (Note: My Yosemite photographs have since been published and displayed by the Yosemite Sierra Visitors Bureau, so these photographs have great value as well.)

As I was putting together the James Gray Gallery show, I joined an organization of photographers called Clickers & Flickers, which met every month at a restaurant in Burbank, where, in a large meeting room, a guest speaker presented his or her photographs to the group.

When Graham Nash (of Crosby, Stills & Nash) abruptly canceled his appearance to discuss his photographic printing business, I was asked if I would like to fill in and address the group. I pulled together one hundred of my best photographs, including many of my bird images, and did my presentation entitled "Photographing Birds and Natural Wonders" on July 25, 2007.

The lecture began with the Allen's Hummingbird chick in the nest at the Santa Monica apartment, and then featured bird photographs taken in the Galapagos and in the rain and cloud forests of Ecuador. It included birds that I had photographed at various parks in California, as well as in my backyard, such as the Scrub Jay Potluck. The talk then used some landscapes I had taken in places such as Yosemite, Kauai, and Vermont, and it concluded with a series of photographs of the hummingbirds in my garden, including the Allen's Hummingbird and Anna's Hummingbird in midair, and a shot of the Black-chinned Hummingbird perched on the rim of the feeder with his wings outspread.

Shortly after that lecture, one of the top printers in Los Angeles, The Icon, offered to sponsor my exhibition at the James Gray Gallery. Over the next few months, I ran test prints of the images that had been selected for the show and made small adjustments of lightness and darkness to some of them in the printing directions. Most of the

photographs printed well just as they were taken by the camera, and no digital enhancement was used on any of the photographs.

For the show, I had a combination of 8 x 12-inch, 10 x 15-inch, and 20 x 30-inch prints, along with one 30 x 45-inch print of an American White Pelican, which has become one of my signature images. Two of the 20 x 30-inch prints featured the Anna's Hummingbird and Allen's Hummingbird flying in my garden, which I had used in the Clickers & Flickers presentation. Two of the 8 x 12-inch prints featured flying hummingbirds as well, and also included photographs of a Scrub Jay with a green grape in his beak (Heidi asked for this one), and a Scrub Jay with an almond in midair as he flipped it into his mouth. My photographs of the Allen's Hummingbird chick from Santa Monica were included, as well as a selection of my bird photographs from the Galapagos.

The show was scheduled to run from February 9, 2008 through March 9, 2008. Shortly before the opening of my show, I had to sign and number each print, as they were limited editions. I did this at the framer, all in one session. It was pretty nerve-racking, but I didn't make one mistake.

If you have an exhibition of your own bird photographs, it's a good idea to get some local publicity for the event. In my case, two days before my show opened, the *Palisadian-Post* newspaper ran a feature about me entitled "Feathered Photography." It was really exciting to see an article about my bird photographs, and one of the three images they used was the one featuring the Scrub Jay with the almond in midair as he flipped it into his mouth. The newspaper made an announcement about the James Gray Gallery show, and I hope that this enticed some people to visit the exhibit.

The grand opening was attended by more than one hundred visitors, and it felt great to see my birds up on the wall as a means of bringing people together for a celebratory event. Partway through the evening, however, one of my friends who collected photographs drew me aside and said in a hushed voice, "There's something wrong with the mats. They're not straight." I hadn't noticed this, but now that he pointed it out, I could see that the corners of the mats were not even. The next day, the framer agreed to redo the mats for each image, and

twenty-four hours later, the show was back up. But this proves that every detail must be considered if you are going to exhibit your bird photographs professionally.

In 2009, I was given an exhibition of twelve bird photographs at the SFO Museum at San Francisco International Airport, entitled "Mathew Tekulsky: Portraits of Birds." The 18 x 24-inch prints were displayed in the Central North Connector of Terminal 3 from February to April, and thousands of people saw these images. They included the Scrub Jay, Band-tailed Pigeon, California Quail, House Finch, and Allen's Hummingbird from my garden in Los Angeles, and the Blue Jay from the garden in Vermont.

My curator for the exhibit, Ramekon O'Arwisters, had a great idea.

"Let's just do bird heads," he said.

I jumped at the opportunity, as I had recently become intrigued with the concept of bird portraiture.

In the display next to the photographs, Ramekon wrote about me that my "intent is to display the likeness, personality, and mood of each bird, in the same manner that traditional portrait photographers capture the emotions and feelings of individual people. For Tekulsky, portrait photography is the best method to acknowledge his adoration for these beautiful animals."

When the show ended, I was told that the workers who took the prints out of the permanent frames hated to see these bird images go. That was very nice to hear.

Another way to share your bird photographs is to join your local Aubudon Society chapter. I did this with the San Fernando Valley Audubon Society a couple of years before my James Gray Gallery show. At that time, I had put together one hundred of my best bird photographs for a gift book entitled *Why We Really, Really Love Birds*. I couldn't get this book published, but the SFVAS asked me to present the images as a slide show at one of their general meetings. I jumped at the chance to be a guest speaker and share my bird photographs with an audience, which I did on November 30, 2006.

Thus began a long association with this organization, which resulted in my photographing many of the group's activities, including their bird walks and general meetings. Some of these photographs

were published in the SFVAS newsletter, the *Phainopepla*. When my NationalGeographic.com column "The Birdman of Bel Air" ended, I had a large number of articles that I had produced but were never posted. Many of these have been published over the last few years in the *Phainopepla*, along with their accompanying bird photographs. Eventually I was asked to join the board of directors of the San Fernando Valley Audubon Society, and I think this was due primarily to my willingness to share my photography with this group.

Another organization in which I have become involved through my bird photography is the John Burroughs Association, named after our nation's greatest natural history author. Some of my bird columns and photographs have been published in the *Wake-Robin*, the newsletter of this organization. John Burroughs was a renowned bird expert, and I feel honored to be allowed to follow in his footsteps with my own observations and photographs of the birds in my garden and elsewhere.

The lesson is that the more you share your bird photographs, the more good things will happen. Many years ago I met the president of a major publishing company, and I expressed my frustration at not having been discovered for my literary talents. "Just keep writing," he told me. I think this applies to photography as well. Just keep taking bird photographs. You never know where this will lead you.

These days, I enjoy sharing my bird photographs on my blog as well as on a special Facebook page devoted to my backyard bird photography. As I post my bird photographs each day, I am always looking forward to the comments that the people who "follow" me make about each photograph. I appreciate it when someone says they "like" a picture, and when they make comments I learn to view my own photographs in a new way. Sometimes, images that I consider good but not great receive compliments by my viewers, and I am forced to take a second look at these images.

For instance, a photograph of an American Robin on the birdbath elicited the following comment from one of my Facebook friends: "Beautiful robin, nicely framed in flowers!" Suddenly, I began to appreciate this image for the way it presents the robin in a natural, reflective moment.

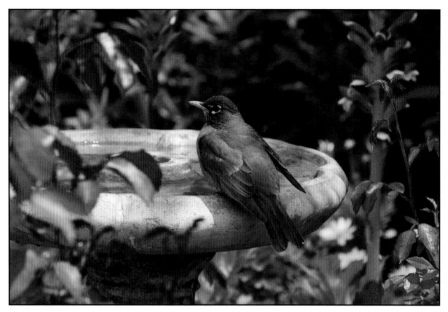

American Robin at birdbath

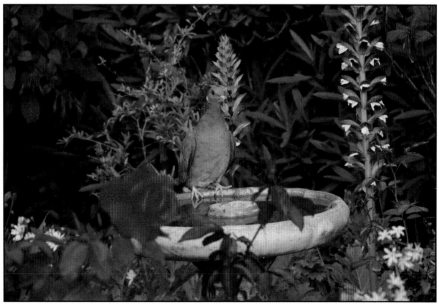

Band-tailed Pigeon at birdbath

On another occasion, I was using the 18–135mm lens to photograph the setup of my oriole feeder and camera on the canyon side of the pool, and when I turned back to look at the main part of the garden, I noticed a Band-tailed Pigeon perched on the birdbath. I had not heard him fly in, and he's a big bird with noisy, flapping wings. But there he was. I moved over a few steps so that I could capture the entire bird's body between the plants that surround the birdbath.

When I posted this photograph, the same Facebook friend made the following comments: "Pigeon, rose, birdbath. Very romantic composition! Nice pic to turn into a postcard with best wishes for someone :)." And another friend added, "This is a very colorful, beautiful photo! Just *love* the flowers and the purple-blue color of the pigeon." Well, to get two messages like this really got my attention. Maybe there *was* something to this photograph. In this way, sharing my photographs on Facebook gives me valuable feedback so that I can determine which of my photographs to choose for a gallery show, or for a book such as this.

Sometimes, comments I receive on my Facebook page motivate me to make extra observations about the birds in my garden. After posting a number of photographs of the Hooded Oriole at the feeder on the canyon side of my yard, one of my Facebook followers asked me how often the oriole visited the feeder. The next day, I made notes about the time of each visit, and I discovered that the oriole visited the feeder sixteen times between 4:00 p.m. and 6:00 p.m. all while I was standing behind my camera from only nine feet away. This convinced me that this oriole has become about as tame as a Hooded Oriole is ever going to be, and I am proud that I have given this bird enough time to build trust with me and allow me to take photographs of him from such close range and out in the open.

One of my best experiences in sharing my bird photographs occurred with two of the Ruby-throated Hummingbird images I took in my Vermont garden during the summer of 2012. I had returned to Los Angeles, and one day my e-mail included an invitation to apply for an exhibition at the Bryan Memorial Gallery in Jeffersonville, Vermont for a show entitled "Click! A Photographer's View of Vermont." By the following February, my two hummingbird photographs were

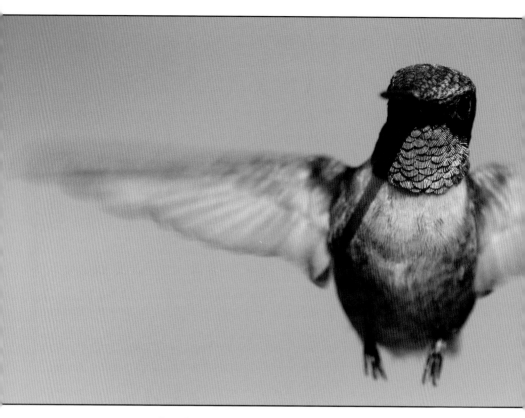

Ruby-throated Hummingbird in exhibition

on display in this juried exhibition. When I was taking these photographs, I had no idea that a few months later they would be hanging on the wall of a prestigious gallery. Now that's what makes it all worthwhile.

Some say that artists are selfish, but I believe that artists are the most generous people in the world. The act of creating an object of art, and then sharing it with the world, is nothing if not a sharing of one's gift and hard work with others. But in return for this act of giving, the artist gets more in return than he would ever be able to give. He gets to be in the moment, creating something beautiful.

Bird photography, in my opinion, takes this principle to the highest level. I look forward each day to the birds that I am going to photo-

graph, and to the interactions that I will have with them. I never know if I will produce a great bird photograph on any given day, but that is part of the challenge. No matter what happens, I know that I will have some quality time as I become absorbed in one of nature's great wonders—the life of the bird.

Ruby-throated Hummingbird in exhibition

Index

Page: 182. Ruby-throated Hummingbird, Adamant, VT, 7/21/12
Tamron 180mm macro lens with Tamron 1.4x teleconverter, ISO 2500,
1/1250 second at f/7.1
It was great to see this photograph being exhibited in a gallery a short
time after I took it.

Author photo (back cover): Mathew Tekulsky, Canon EOS 7D camera
with Canon 100–400mm lens, Adamant, VT, 7/15/12
Canon 18-135 lens at 62mm, ISO 640, 1/400 second at f/11
I enjoy a relaxing moment between photography sessions in my
garden in Adamant.

Page: 168. Birdfeeders and camera, Adamant, VT, 7/29/12
Canon 18–135 lens at 18mm, ISO 200, 1/160 second at f/8
The afternoon area of my garden in Adamant, looking back toward the morning area. From left to right: ground feeder tray with mixed birdseed; green platform feeder on a pole, with unshelled, unsalted, roasted peanuts; metal platform feeder with mixed birdseed; wood platform feeder with black oil sunflower seed; wood platform feeder with peanuts; tube feeder with Nyjer seed; green platform feeder on a pole, with mixed birdseed; on a tripod behind the feeders, my Canon EOS 7D camera body with a Canon 100–400mm lens. In the far background, you can see the red hummingbird feeder hanging from a pole.

Page: 170. Allen's Hummingbird female with chicks in nest, Sherman Oaks, CA, 5/18/12
Tamron 180mm macro lens with Tamron 1.4x teleconverter and Canon Speedlite 600 EX-RT external flash, ISO 400, 1/60 second at f/4.5
This hummingbird allowed me to get close to her as she fed her chicks. I had to keep very still as I photographed, so as not to flush her off of the nest.

Page: 178 (top). American Robin, Los Angeles, CA, 5/9/13
Canon 100–400mm lens at 250mm, ISO 400, 1/500 second at f/8
This photograph was taken in the early afternoon, with the sun producing a pleasing blanket of light on the bird's back.

Page: 178 (bottom). Band-tailed Pigeon, Los Angeles, CA, 5/17/13
Canon 18–135mm lens at 135mm, ISO 800, 1/400 second at f/7.1
The combination of this elegant bird and the domestic setting of my garden makes this image so compelling.

Page: 180. Ruby-throated Hummingbird, Adamant, VT, 7/12/12
Tamron 180mm macro lens with Tamron 1.4x teleconverter, ISO 1250, 1/800 second at f/6.3
Just months after taking this photograph, a limited edition print of this image was on display in a gallery.

Page: 160 (bottom). American Goldfinch, Adamant, VT, 7/9/12
Canon 100–400mm lens at 400mm, ISO 640, 1/800 second at f/9
Taken eleven seconds later. The goldfinch poked her head out from the left side of the feeder.

Page: 162 (top). American Goldfinch, Adamant, VT, 7/9/12
Canon 100–400mm lens at 400mm, ISO 400, 1/500 second at f/8
The goldfinch jumped over to this perch at exactly 3:51 p.m., and this photograph was taken forty-four seconds later. She flew off fifteen seconds after that. The whole episode took less than a minute and a half.

Page: 162 (bottom). Black-capped Chickadee, Adamant, VT, 7/20/12
Canon 100–400mm lens at 400mm, ISO 1250, 1/500 second at f/8
Early in the morning, the chickadee pauses for a moment to have his portrait made.

Page: 164 (top). Ruby-throated Hummingbird, Adamant, VT, 7/13/12
Canon 100–400mm lens at 400mm, ISO 3200, 1/800 second at f/9
Since this hummingbird was in the shade, I had to photograph at a higher ISO than usual.

Page: 164 (bottom0. Purple Finch, Adamant, VT, 7/28/12
Canon 100–400mm lens at 400mm, ISO 800, 1/500 second at f/8
I enjoy listening to the warbling song of this bird. He's pretty wary, but I got close enough to take this photograph.

Page: 166. View from morning area to afternoon area of the garden; hummingbird feeder in foreground, birdfeeders and camera in background, Adamant, VT, 7/30/12
Tamron 10–24mm lens at 10mm, ISO 640, 1/500 second at f/13
In the foreground, the hummingbird feeder in the morning area of my garden in Adamant; in the background, the afternoon area of the garden, with the Nyjer feeder, platform feeders, ground feeder tray, as well as my camera mounted on a tripod.

Page: 155. Ruby-throated Hummingbird, Adamant, VT, 7/13/12
Canon 100–400mm lens at 400mm, ISO 1600, 1/1250 second at f/13
The bee balm flowers are an important element in the composition of
this photograph.

Page: 156. American Goldfinch, Adamant, VT, 6/30/12
Canon 100-400mm lens at 400mm, ISO 200, 1/400 second at f/7.1
The pink rose flowers in the upper left corner enliven this image. The
bird's slightly tilted pose gives him character, and the Nyjer seeds add
an element of texture.

Page: 156. Blue Jay, Adamant, VT, 7/1/12
Canon 100–400mm lens at 400mm, ISO 640, 1/800 second at f/9
You can see one of the black oil sunflower seeds in the beak of this
Blue Jay. I raised the platform feeder off the ground by placing it on a
patio table.

Page: 158 (top). Camera, hummingbird feeder, and platform feeder with
peanuts, Adamant, VT, 7/13/12
Canon 18–135 lens at 28mm, ISO 200, 1/250 second at f/10
The morning area of my garden in Adamant, showing the hummingbird
feeder with the two backgrounds that I use: the green grass across the
driveway, and the pink rose flowers at the right of the frame. I can
rotate the camera to the left to photograph the Blue Jay if he lands at
the platform feeder to gather a peanut.

Page: 158 (bottom). Blue Jay, Adamant, VT, 7/22/12
Canon 100–400mm lens at 400mm, ISO 1000, 1/1600 second at f/14
This Blue Jay looks as if he is guarding the peanuts in the wood
platform feeder.

Page: 160 (top). American Goldfinch, Adamant, VT, 7/9/12
Canon 100–400mm lens at 400mm, ISO 400, 1/500 second at f/8
Taken at 3:50 p.m. and thirty-six seconds. The goldfinch poked her
head out from the right side of the feeder.

This image features the female Black-chinned Hummingbird with the Mexican marigold flowers in the background.

Page: 145. Anna's Hummingbird, Los Angeles, CA, 6/26/13
Canon 100–400mm lens at 400mm, ISO 1600, 1/2000 second at f/9
Sometimes, everything falls into place. The trick is to position yourself behind the camera when this happens.

Page: 147. Allen's Hummingbird, Los Angeles, CA, 5/24/13
Canon 100–400mm lens at 400mm, ISO 2000, 1/1600 second at f/5.6
Contrast creates drama in a scene. Here, the bird and the Mexican sage are backlit against a dark background.

Page: 149. View across pool into the main part of the garden, Los Angeles, CA, 5/13/13
Canon 18–135 lens at 18mm, ISO 200, 1/250 second at f/10
In the corner of the house at left, you can see the sliding glass window where I photograph the main part of my garden in Los Angeles from the "blind" inside the TV room. Note the hummingbird feeder and birdbath, and the red fuchsia flowers and yellow bush daisy flowers behind the birdbath, both of which serve as backdrops for my bird photographs.

Page: 151. Black-chinned Hummingbird close-up, Los Angeles, CA 6/16/13
Canon 100-400mm lens at 400mm, ISO 500, 1/640 second at f/9
The purple throat feathers of this hummingbird are highlighted in this detail of the same image from page 97.

Page: 152. Ruby-throated Hummingbird, Adamant VT, 7/13/12
Canon 100–400mm lens at 250mm, ISO 400, 1/800 second at f/9
Featuring the top of the bird's head in this photograph was intentional, as I try to be an amateur naturalist and document many views of the birds I photograph.

Page: 136. Scrub Jay, Los Angeles, CA, 11/20/12
Canon 100–400mm lens at 400mm, ISO 500, 1/640 second at f/8
The brown color of the acorn is a strong element in this photograph.

Page: 138. Scrub Jay, Los Angeles, CA 7/5/13
Canon 100–400mm lens at 400mm, ISO 400, 1/640 second at f/9
Scrub Jays have a sweet tooth, and donut holes are no exception.

Page: 139. Hooded Oriole, Los Angeles, CA, 5/19/13
Canon 100–400mm lens at 400mm, ISO 400, 1/500 second at f/9
The yellow of the bird and the golden hue of the Mexican marigold in
the background combine for a spectacular result.

Page: 141 (top). Hooded Oriole, Los Angeles, CA, 7/8/13
Canon 100–400mm lens at 400, ISO 400, 1/640 second at f/9
When the bird perches before he goes to the feeder, this offers
interesting photographic possibilities.

Page: 141 (bottom). Hooded Oriole, Los Angeles, CA, 7/7/13
Canon 100–400mm lens at 400mm, ISO 320, 1/640 second at f/8
Sometimes, a longer shot that shows the bird in its environment can
be as satisfying as a closer shot of the same bird. In this photograph,
you can see by the bird's wet underside that he has recently taken a
bath.

Page: 142. Allen's Hummingbird, Los Angeles, CA, 1/19/13
Canon 100–400mm lens at 400mm, ISO 400, 1/500 second at f/11
Profiles allow you to get as much of the bird in focus as possible.

Page: 143. Allen's Hummingbird, Los Angeles, CA, 6/18/13
Canon 100–400mm lens at 400mm, ISO 1600, 1/2000 second at f/8
Every photograph of the Allen's Hummingbird at the Mexican sage
has its own value. In this case, top lighting makes the image special.

Page: 144. Black-chinned Hummingbird, Los Angeles, CA, 6/16/13
Canon 100–400mm lens at 400mm, ISO 400, 1/640 second at f/9

Page: 122 (top). American Robins, Los Angeles, CA, 2/8/13
Canon 100–400mm lens at 400mm, ISO 800, 1/160 second at f/5.6
Early one winter morning, I photographed these two American Robins competing for a spot at the birdbath.

Page: 122 (bottom). Scrub Jay, Los Angeles, CA, 3/26/13
Canon 100–400mm lens at 340mm, ISO 800, 1/1250 second at f/5.6
It is really fun to use the droplets of water created by a bathing bird as an element in a photograph.

Page: 124. Band-tailed Pigeon, Los Angeles, CA, 6/19/13
Canon 100–400mm lens at 400mm, ISO 400, 1/640 second at f/9
By remaining still, I built up the trust of this Band-tailed Pigeon as he posed for me on the platform feeder.

Page: 124. Acorn Woodpecker, Los Angeles, CA, 4/7/13
Canon 100–400mm lens at 400mm, ISO 400, 1/500 second at f/8
This image could have been taken in a national park, but it was in my yard, with the far side of the canyon as a background.

Page: 127. Blue Jay and eastern chipmunk, Adamant, VT, 7/11/12
Canon 18–135mm lens at 135mm, ISO 1000, 1/400 second at f/8
The Blue Jay and the chipmunk share some mixed birdseed at the feeder. What could be more charming?

Page: 132. Lesser Goldfinch, Los Angeles, CA, 10/2/12
Canon 100–400mm lens at 400mm, ISO 400, 1/640 second at f/8
A view of the Lesser Goldfinch as he makes his way over to the Nyjer feeder in the main part of the garden.

Page: 135. Scrub Jay, Los Angeles, CA, 4/18/13
Canon 100–400mm lens at 400mm, ISO 400, 1/640 second at f/9
When I saw the Scrub Jay tilt his head with the peanut, I clicked the shutter right away.

Page: 136. Scrub Jay, Los Angeles, CA, 4/17/13
Canon 100–400mm lens at 400mm, ISO 400, 1/800 second at f/10
The Scrub Jay strikes a majestic pose in this image.

Page: 113. Hooded Oriole, Los Angeles, CA, 3/26/13
Canon 100–400mm lens at 100mm, ISO 800, 1/1600 second at f/6.3
I had to act fast to capture this Hooded Oriole before he flew out of the frame. Getting to know the habits of the birds that visit your garden will prepare you for moments such as this.

Page: 114. American Goldfinches and Purple Finches, Adamant, VT, 7/21/12
Canon 100–400mm lens at 135mm, ISO 640, 1/400 second at f/6.3
Zooming out to get the shot, in this case an American Goldfinch descending onto a platform feeder that is occupied by another goldfinch and three Purple Finches.

Page: 115. Allen's Hummingbird, Los Angeles, CA, 4/28/12
Canon 100–400mm lens at 400mm, ISO 400, 1/500 second at f/10
In this image, I positioned the hummingbird against the green foliage so the subject would stand out against the darker background.

Page: 118. Hooded Oriole, Los Angeles, CA, 4/9/13
Canon 100–400mm lens at 400mm, ISO 400, 1/500 second at f/8
Placing this Hooded Oriole between two patches of bush daisy flowers was not an accident. I had to focus and press the shutter in the instant that he landed on his perch and faced me, before he turned sideways to drink.

Page: 120. Bullock's Oriole, Los Angeles, CA, 3/23/13
Canon 100–400mm lens at 340mm, ISO 400, 1/400 second at f/7.1
This was the only time the Bullock's Oriole visited my yard.

Page: 121. Golden-crowned Sparrow (background) and House Finch (foreground), Los Angeles, CA, 2/3/13
Canon 100–400mm lens at 400mm, ISO 800, 1/500 second at f/7.1
I pressed down on the shutter just when the Golden-crowned Sparrow flapped his wings in the water.

Page: 103. Scrub Jay, Los Angeles, CA, 7/8/13
Canon 100–400mm lens at 400mm, ISO 400, 1/640 second at f/9
The juvenile Scrub Jay perches on a bear's breeches stalk before
jumping over to the platform feeder.

Page: 104. Scrub Jay, Los Angeles, CA, 7/5/13
Canon 100–400mm lens at 400mm, ISO 400, 1/640 second at f/8
When the bear's breeches stalk grew up behind the platform feeder, it
became useful as a compositional element.

Page: 105. Black-chinned Hummingbird, Los Angeles, CA, 4/28/12
Canon 100–400mm lens at 400mm, ISO 2000, 1/1600 second at f/9
A sense of balance is achieved between the hummingbird and the
bottlebrush flowers.

Page: 106. Black-chinned Hummingbird, Los Angeles, CA, 5/10/13
Canon 100–400mm lens at 400mm, ISO 2000, 1/2000 second at f/10
This hummingbird is drinking nectar at a fuchsia flower. There is a lot
of color in this photograph.

Page: 107. Allen's Hummingbird, Los Angeles, CA, 5/29/13
Canon 100–400mm lens at 400mm, ISO 1600, 1/2000 second at f/1
In the background, the lower half of the frame is the patio, while the
upper half is the main part of the garden.

Page: 109. Allen's Hummingbird, Los Angeles, CA, 5/30/13
Canon 100–400mm lens at 400mm, ISO 1600, 1/2000 second at f/8
Photographing the hummingbird as it approaches the flower allows
me to get the entire bird, including the bill, into the image.

Page: 110. Allen's Hummingbird, Los Angeles, CA, 4/22/13
Canon 100–400mm lens at 400mm, ISO 400, 1/500 second at f/10
This hummingbird seems to be posing for me as he raises his wing in
a kind of greeting.

Page: 97. Black-chinned Hummingbird, Los Angeles, CA, 6/16/13
Canon 100–400mm lens at 400mm, ISO 500, 1/640 second at f/9
In this image, I captured the male Black-chinned Hummingbird with the Mexican marigold flowers in the background.

Page: 98. Lesser Goldfinches, Los Angeles, CA, 10/10/12
Canon 100–400mm lens at 100mm, ISO 800, 1/1000 second at f/11
I did not plan on the bird at the right flying into the shot, but I'm glad he did.

Page: 99. Nanday Parakeets and moon, Los Angeles, CA, 11/24/12
Canon 100–400mm lens at 400mm, ISO 100, 1/1250 second at f/5.6
This is a magical image. I followed the birds with my camera as they moved across the sky.

Page: 100. Allen's Hummingbird, Los Angeles, 6/25/13
Canon 100–400mm lens at 400mm, ISO 640, 1/800 second at f/10
The hummingbird, perched on the oriole feeder, is just about to poke his beak into the feeder hole for some sugar water.

Page: 101. Scrub Jay, Los Angeles, CA, 1/19/13
Canon 100–400mm lens at 285mm, ISO 400, 1/640 second at f/9
Sometimes you just want to try something different, such as photographing the bird's shadow as well as the shadow of the peanut in his beak.

Page: 102 (top). Ruby-throated Hummingbird, Adamant, VT, 7/21/12
Tamron 180mm macro lens with Tamron 1.4x teleconverter, ISO 2000, 1/1000 second at f/7.1
This hummingbird surprised me when he landed on the opposite side of the feeder and faced me directly.

Page: 102 (bottom). Purple Finch, Adamant, VT, 7/29/12
Canon 100–400mm lens at 400mm, ISO 800, 1/500 second at f/8
The background of this image was created by the overcast sky and the pattern of the leaves.

Page: 90 (bottom). Allen's Hummingbird, Los Angeles, CA, 1/11/13
Canon 100–400mm lens at 400mm, ISO 1250, 1/800 second at f/10
The glow of the hummingbird's gorget is the centerpiece of this photograph.

Page: 91. Orange-crowned Warbler, Los Angeles, CA, 1/21/13
Canon 100–400mm lens at 320mm, ISO 640, 1/500 second at f/8
Photography is all about the light. In this image, I used backlighting, and this resulted in the reflections on the water and on the rim of the birdbath.

Page: 92. Golden-crowned Sparrow, Los Angeles, CA, 2/6/13
Canon 100–400mm lens at 400mm, ISO 640, 1/400 second at f/7.1
Photographing at midday, with the sun directly above the bird, produced this image.

Page: 93. Yellow-rumped Warbler, Los Angeles, CA, 4/4/13
Canon 100–400mm lens at 400mm, ISO 200, 1/400 second at f/7.1
This vertical crop makes the most of the bird's reflection in the water of the birdbath.

Page: 94. Allen's Hummingbird, Los Angeles, CA, 5/1/13
Canon 100–400mm lens at 390mm, ISO 400, 1/500 second at f/8
The hummingbird's head is placed between the yellow flowers of the bush daisy.

Page: 95. Black-chinned Hummingbird, Los Angeles, CA, 5/2/13
Canon 100–400mm lens at 400mm, ISO 400, 1/500 second at f/11
This bird tilted her head to look at me, and I captured the moment.

Page: 96. Black-chinned Hummingbird, Los Angeles, CA, 5/2/13
Canon 100–400mm lens at 235mm, ISO 400, 1/500 second at f/10
I let the bird perch at the hole closest to me so I could photograph her green back.

Page: 84. California Towhee, Los Angeles, CA, 1/5/13
Canon 100–400mm lens at 250mm, ISO 640, 1/125 second at f/5.6
Note the reflections in the water, which create a sense of beauty in this image.

Page: 85. Ruby-throated Hummingbird, Adamant, VT, 7/17/12
Canon 100–400mm lens at 400mm, ISO 1600, 1/1250 second at f/13
Each of the bird's wings hits the pink flowers, while the large depth of field gets most of the bird's body in focus.

Page: 86 (top). Yellow-rumped Warbler, Los Angeles, CA, 10/30/12
Canon 100–400mm lens at 400mm, ISO 500, 1/320 second at f/6.3
This is a good example of how a photograph that is not taken in direct sunlight can reveal a richness of color.

Page: 86 (bottom). Wrentit, Los Angeles, CA, 4/20/13
Canon 100–400mm lens at 400mm, ISO 400, 1/640 second at f/9
Every now and then, I get an opportunity to photograph a reclusive bird, such as this Wrentit taking a bath.

Page: 88 (top). Ruby-throated Hummingbird, Adamant, VT, 7/11/12
Tamron 180mm macro lens with Tamron 1.4x teleconverter, ISO 2500, 1/1250 second at f/8
This image shows the green back of the hummingbird while he hovers above the feeder.

Page: 88 (bottom). Hooded Oriole, Los Angeles, CA, 4/6/13
Canon 100–400mm lens at 400mm, ISO 400, 1/640 second at f/8
The Hooded Oriole from seven feet away, taken through the open window in my TV room.

Page: 90 (top). Scrub Jay, Los Angeles, CA, 3/15/13
Canon 100–400mm lens at 400mm, ISO 400, 1/1250 second at f/8
The peanuts for the Scrub Jay are just off-camera to the left, and he is looking right at them.

Page: 70. Allen's Hummingbird, Los Angeles, CA, 7/29/13
Tamron 180mm macro lens with Tamron 1.4x teleconverter, ISO 500, 1/250 second at f/8
This image reveals the bird's personality in the way he is looking at me.

Page: 71. California Quail, Los Angeles, CA, 6/12/13
Canon 100–400mm lens at 400mm, ISO 400, 1/1000 second at f/7.1
This quail stands on the platform feeder, waiting for his birdseed.

Page: 73. Hooded Oriole, Los Angeles, CA, 4/7/13
Canon 100–400mm lens at 400mm, ISO 400, 1/640 second at f/8
The male Hooded Oriole is wary and aggressive at the same time, but I think he appreciates the fact that I provide him with sugar water from March to September.

Page: 75. Hooded Oriole, Los Angeles, CA, 5/22/13
Canon 100–400mm lens at 400mm, ISO 400, 1/640 second at f/9
Up close and personal with the Hooded Oriole, from about nine feet away.

Page: 75 (top). California Quail, Los Angeles, CA, 4/27/13
Canon 100–400mm lens at 400mm, ISO 400, 1/500 second at f/11
A casual moment for the California Quail, as he strolls across the garden right in front of me.

Page: 78 (bottom). American Goldfinches, Adamant, VT, 7/12/12
Canon 100–400mm lens at 250mm, ISO 400, 1/800 second at f/9
When the American Goldfinches gather at the Nyjer feeder, you never know what will happen as the birds compete for perches and birdseed.

Page: 83. Allen's Hummingbird, Los Angeles, CA, 1/26/13
Canon 100–400 lens at 260mm, ISO 1600, 1/2000 second at f/10
I photographed this hummingbird with his wings outspread, just before he took flight.

Page: 62. Scrub Jay, Los Angeles, CA, 1/10/13
Canon 100–400mm lens at 400mm, ISO 250, 1/500 second at f/8
The Scrub Jay pauses to look up at me. I love the lines in this image, running from upper right to lower left, then from upper left to lower right, drawing the viewer's attention to the Scrub Jay's eye.

Page: 65. Ruby-throated Hummingbird, Adamant, VT, 6/29/12
Canon 100–400mm lens at 400mm, 800 ISO, 1/800 second at f/10
The red of the hummingbird feeder and the red of the hummingbird's gorget complement each other.

Page: 66 (top). Ruby-throated Hummingbird, Adamant, VT, 7/1/12
Canon 100–400mm lens at 400mm, ISO 1250, 1/1600 second at f/11
This Ruby-throated Hummingbird female seems as surprised as I am to see ourselves looking at each other.

Page: 66 (bottom). Ruby-throated Hummingbird, Adamant, VT, 7/9/12
Canon 180mm macro lens with Tamron 1.4x teleconverter, ISO 2500, 1/1250 second at f/7.1
I was fortunate to get the eye in focus as this hummingbird hovered while drinking the sugar water from the feeder.

Page: 67. Ruby-throated Hummingbird, Adamant, VT, 7/10/12
Tamron 180mm macro lens with Tamron 1.4x teleconverter, ISO 2500, 1/1250 second at f/8
The click of the shutter caused this bird to raise his wings, but he stayed on the feeder.

Page: 68. Ruby-throated Hummingbird, Adamant, VT, 7/4/12
Canon 100–400mm lens at 400mm, ISO 1250, 1/1600 second at f/9
This hummingbird got used to me over time, and he allowed me to get even closer than this.

Page: 69. Ruby-throated Hummingbird, Adamant, VT, 7/11/12
Tamron 180mm macro lens with Tamron 1.4x teleconverter, ISO 2500, 1/1250 second at f/8
Getting close to a hummingbird is a gradual process.

Page: 48. Scrub Jay, Los Angeles, CA, 2/12/13
Canon 18–135mm lens at 35mm, ISO 1000, 1/2500 second at f/8
Shadows of myself (as I take this picture), the tripod and second camera body with the 100–400mm lens (below the feeder), as well as the shadow of the bird and of the peanut in the bird's beak.

Page: 49. Allen's Hummingbird chicks in nest, Sherman Oaks, CA, 5/16/12
Canon 50mm macro lens with Canon Speedlite 600 EX-RT external flash, ISO 1250, 1/160 second at f/5.6
I focused on the eye of the bird at the front of this nest. The multicolored background adds to the composition.

Page: 50. Allen's Hummingbird female with chicks in nest, Sherman Oaks, CA, 5/25/12
Tamron 180mm macro lens with Tamron 1.4x teleconverter and Canon Speedlite 600 EX-RT external flash, ISO 400, 1/60 second at f/5
One chick's head is visible at the left, and the second chick is hidden behind the mother's body.

Page: 51. Allen's Hummingbird, Los Angeles, CA, 6/22/13
Canon 100–400mm lens at 400, ISO 400, 1/1000 second at f/8
I used a 42-inch circular reflector for this photograph. It was mounted on a stand and reflected the sun's light back onto the bird's body from the left side of the frame.

Page: 52. Allen's Hummingbird, Los Angeles, CA, 6/19/13
Canon 100–400mm lens at 400mm, ISO 400, 1/640 second at f/9
The sunlight draws the viewer's eye to the brilliant gorget of this hummingbird.

Page: 58. Allen's Hummingbird, Los Angeles, CA, 6/19/13
Canon 100–400mm lens at 400mm, ISO 400, 1/800 second at f/9
When you can capture an emotion in a photograph, it is a special moment, as with this inquisitive glance (or is it a stare?) from the Allen's Hummingbird.

Page: 38. Hooded Oriole, Los Angeles, CA, 5/24/13
Canon 100–400mm lens at 390mm, ISO 400, 1/500 second at f/5.6
The Hooded Oriole waits for me to put the oriole feeder back on the pole after I have been photographing the hummingbirds in the main garden. By taking the oriole feeder off of the pole, I make sure the hummingbirds only go to the hummingbird feeder while I am photographing them.

Page: 43. Nanday Parakeet, Los Angeles, CA, 6/13/13
Canon 100–400mm lens at 400mm, ISO 400, 1/640 second at f/9
The Nanday Parakeet has become familiar with me, and he now allows me to photograph him from close range.

Page: 44 (top). Nanday Parakeets, Los Angeles, CA, 6/19/13
Canon 100–400mm lens at 150mm, ISO 400, 1/500 second at f/8
The parakeet that is perched on the bear's breeches plant at the lower left almost blends into the background.

Page: 44 (bottom). Hooded Oriole, Los Angeles, CA, 6/25/13
Canon 100–400mm lens at 400mm, ISO 400, 1/800 second at f/9
A study in orange and yellow. Working with colors is an important aspect of composition in bird photography.

Page: 45. Hooded Oriole, Los Angeles, CA, 5/22/13
Canon 100–400mm lens at 100mm, ISO 400, 1/500 second at f/9
With the zoom set at a wider angle, the bird appears smaller in the frame and you can see more of his environment.

Page: 46. Hooded Oriole, Los Angeles, CA, 7/19/13
Canon 100–400mm lens at 100mm, ISO 6400, 1/8000 second at f/8
The Hooded Oriole is still looking at me as he flies off of the feeder.

Page: 47. Scrub Jay, Los Angeles, CA, 2/22/13
Canon 100–400mm lens at 400mm, ISO 400, 1/500 second at f/8
I captured the peanut in just the right position.

Page: 31 (bottom). Birdfeeders and camera, Los Angeles, CA, 7/2/13
Canon 18–135mm lens at 18mm, ISO 200, 1/250 second at f/10
Looking out from the main part of my garden in Los Angeles, from
left to right: green platform feeder, partially hidden in the plants;
hummingbird feeder; on a tripod, my Canon EOS 7D camera body
with a Canon 100–400mm lens; tube feeder with Nyjer seed, in the
background across the pool; oriole feeder. The birdbath is hidden
behind the flowers at left.

Page: 32. Birdfeeders and camera, Adamant, VT, 7/29/12
Canon 18–135mm lens at 18mm, ISO 200, 1/200 second at f/9
The afternoon area of my garden in Adamant. From left to right: green
platform feeder on a pole, with mixed birdseed; tube feeder with
Nyjer seed; wood platform feeder with unshelled, unsalted, roasted
peanuts; wood platform feeder with black oil sunflower seed; metal
platform feeder with mixed birdseed; green platform feeder on a pole,
with peanuts; ground feeder tray with mixed birdseed; on a tripod
behind the feeders, my Canon EOS 7D camera body with a Canon
100–400mm lens.

Page: 33. Golden–crowned Sparrow, Los Angeles, CA, 2/26/13
Canon 100–400mm lens at 400mm, ISO 400, 1/800 second at f/10
When the Golden–crowned Sparrow picked up the peanut, I clicked
the shutter to document this rare moment.

Page: 34. Hermit Thrush, Los Angeles, CA, 4/13/13
Canon 100–400mm lens at 400mm, ISO 1600, 1/400 second at f/7.1
This bird spends a lot of time at my birdbath during the winter and
early spring. His song is one of the sweetest sounds I have ever
heard.

Page: 36. Hooded Oriole, Los Angeles, CA, 4/12/13
Canon 100–400mm lens at 400mm, ISO 1600, 1/1000 second at f/5.6
There's something marvelous about the yellow–orange oriole with the
drops of water all around him.

The towhee has just hopped onto the brick patio from the ground feeder to the right.

Page: 26. Golden–crowned Sparrow, Los Angeles, CA, 1/11/13
Canon 100–400mm lens at 400mm, ISO 320, 1/800 second at f/9
Many times, a bird will emerge from behind some plants. If you keep still enough, he will remain in that area for a while.

Page: 27 (top). Fox Sparrow, Los Angeles, CA, 1/16/13
Canon 100–400mm lens at 400mm, ISO 320, 1/640 second at f/8
This shy bird became accustomed to me as I got down to his level.

Page: 27 (bottom). Dark–eyed (Oregon) Junco, Los Angeles, CA, 1/11/13
Canon 100–400mm lens at 400mm, ISO 250, 1/640 second at f/8
This junco is framed by the green foliage on either side of the bird.

Page: 28. Scrub Jay, Los Angeles, CA, 2/16/13
Canon 100–400mm lens at 275mm, ISO 320, 1/1250 second at f/7.1
I like to photograph the bird when he is perched on the rim of the feeder. Here, you can see the entire bird, as well as the feeder and the birdseed.

Page: 29. California Quail, Los Angeles, CA, 11/21/12
Canon 100–400mm lens at 400mm, ISO 160, 1/500 second at f/7.1
The regal presence of this quail captured my imagination.

Page: 30. Lesser Goldfinch (left) and Pine Siskin (right), Los Angeles, CA, 10/26/12
Canon 100–400mm lens at 285mm, ISO 400, 1/800 second at f/10
The Pine Siskin is a rare visitor to my yard, but the Lesser Goldfinch is here every day.

Page: 31 (top). Birdfeeders and birdbath, Los Angeles, CA, 7/2/13
Canon 18–135mm lens at 18mm, ISO 200, 1/320 second at f/10
Looking in at the main part of my garden in Los Angeles, from left to right: oriole feeder; tube feeder with Nyjer seed; green platform feeder on a pole; hummingbird feeder; birdbath.

The texture of the driveway makes an interesting background in this image.

Page: 14. Ruby–throated Hummingbird, Adamant, VT, 7/4/12
Canon 100–400mm lens at 400mm, ISO 1250, 1/2000 second at f/8
I had to anticipate where the hummingbird would be flying after he had a drink, and I picked the right spot.

Page: 16. American Goldfinch, Adamant, VT, 6/30/12
Canon 100–400mm lens at 400mm, ISO 200, 1/500 second at f/8
The yellow of the bird works well with the yellow of the feeder perch.

Page: 18. Allen's Hummingbird, Los Angeles, CA, 1/16/13
Canon 100–400mm lens at 400mm, ISO 400, 1/400 second at f/7.1
The halo around this hummingbird is a special effect that adds to the backlighting of the subject.

Page: 23. View of canyon side of pool with oriole feeder, Mexican sage, and Mexican marigold, Los Angeles, CA, 6/1/13
Tamron 10–24mm lens at 10mm, ISO 200, 1/320 second at f/10
View looking toward the canyon from the main part of my garden in Los Angeles. The palm tree where the Hooded Oriole nests is in the background at left, behind the Mexican marigold. The oriole feeder is on the canyon side of the pool, hanging just above the purple Mexican sage.

Page: 24. Blue Jay, Adamant, VT, 7/3/12
Canon 100–400mm lens at 400mm, ISO 640, 1/1000 second at f/10
I arranged the peanuts in the platform feeder carefully as part of the composition.

Page: 25 (top). Song Sparrow, Los Angeles, CA, 1/16/13
Canon 100–400mm lens at 400mm, ISO 200, 1/500 second at f/8
This Song Sparrow showed no fear of me as long as I remained still.

Page: 25 (bottom). Spotted Towhee, Los Angeles, CA, 1/30/13
Canon 100–400mm lens at 400mm, ISO 400, 1/800 second at f/10

Page: 8 (top). Hooded Oriole, Los Angeles, CA, 7/8/13
Canon 100–400mm lens at 400mm, ISO 400, 1/640 second at f/9
The spikes of lavender in the background, the reflection of the garden
in the feeder, and the bird himself, combine well in this image.

Page: 8 (bottom). Mourning Dove, Los Angeles, CA, 4/18/13
Canon 100–400mm lens at 400mm, ISO 400, 1/800 second at f/9
A common bird can look magnificent when placed in front of a colorful
background.

Page: 9. Bushtit, Los Angeles, CA, 5/14/13
Canon 100–400mm lens at 400mm, ISO 400, 1/400 second at f/13
The birdbath is one of the few places you will see the Bushtit perched
for more than a moment.

Page: 10 (top). Hooded Oriole, Los Angeles, CA, 9/1/12
Canon 100–400mm lens at 400mm, ISO 640, 1/800 second at f/10
The juvenile Hooded Oriole consumes large quantities of sugar water
in preparation for the migration south.

Page: 10 (bottom). Scrub Jay, Los Angeles, CA, 2/22/13
Canon 100–400mm lens at 400mm, ISO 400, 1/640 second at f/9
I like the look of the peanut against the lighter background area.

Page: 11. Allen's Hummingbird, Los Angeles, CA, 2/3/13
Canon 100–400mm lens at 400mm, ISO 1600, 1/1600 second at f/11
This bird of paradise flower gives me the opportunity for natural
images in my own backyard.

Page: 12. Hooded Oriole, Los Angeles, CA, 3/21/13
Canon 100–400mm lens at 400mm, ISO 400, 1/400 second at f/7.1
The Hooded Oriole drinks nectar from the bird of paradise flower, as
do the hummingbirds.

Page: 13. Blue Jay, Adamant, VT, 7/13/12
Canon 100–400mm lens at 400mm, ISO 800, 1/1000 second at f/11

About the Photographs

Page: x. Scrub Jay, Los Angeles, CA, 6/14/13
Canon 100–400mm lens at 400mm, ISO 400, 1/640 second at f/8
Sometimes a simple portrait of a bird can be very effective.

Page: 2. Nanday Parakeets, Los Angeles, CA, 11/24/12
Canon 100–400mm lens at 400mm, ISO 100, 1/800 second at f/5.6
It is always exciting to see the Nanday Parakeets flying over my garden, screeching as they go.

Page: 5. Scrub Jay, Los Angeles, CA, 6/20/12
Canon 100–400mm lens at 310mm, ISO 800, 1/800 second at f/10
The focal point of the eye is complemented by the detail of the chest feathers, and the tail at the left of the frame is balanced by the dark spaces in the foliage at the right.

Page: 6. House Finch, Los Angeles, CA, 6/14/13
Canon 100–400mm lens at 400mm, ISO 400, 1/640 second at f/9
This familiar bird looks bright and colorful in this photograph.

Page: 6. Allen's Hummingbird, Los Angeles, CA, 5/22/13
Canon 100–400mm lens at 400mm, ISO 1600, 1/2000 second at f/11
The purple of the Mexican sage works well with the pink of the azaleas in the background. The bird emerges out of a mass of color.

Page: 7 Northern Mockingbird, Los Angeles, CA, 4/20/13
Canon 100–400mm lens at 400mm, ISO 800, 1/800 second at f/10
The sprinkler head accentuates the backyard environment, while the bird retains his wildness.

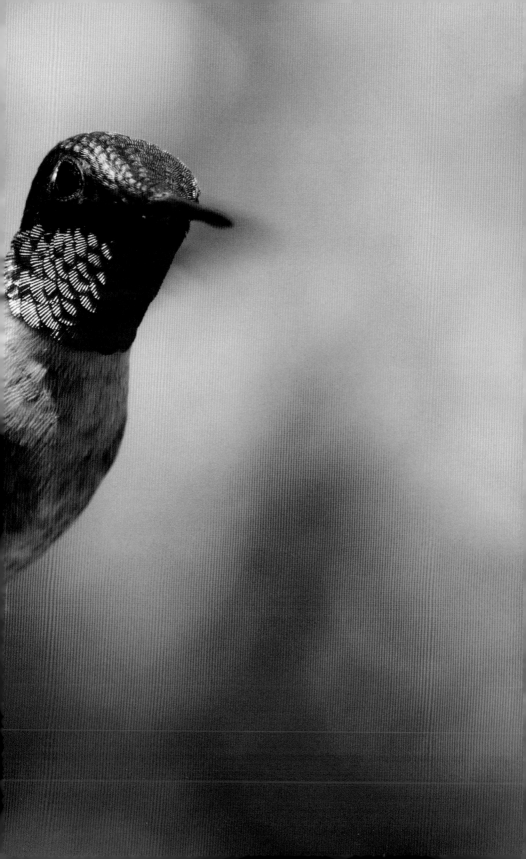